T0209678

An Analysis of

Alasdair MacIntyre's

After Virtue

Jon W. Thompson

Published by Macat International Ltd
24:13 Coda Centre, 189 Munster Road, London SW6 6AW.

Distributed exclusively by Routledge
2 Park Square, Milton Park, Abingdon, Oxon OX14 4RN
711 Third Avenue, New York, NY 10017, USA

Routledge is an imprint of the Taylor & Francis Group, an informa business

www.macat.com
info@macat.com

Cataloguing in Publication Data
A catalogue record for this book is available from the British Library.
Library of Congress Cataloguing-in-Publication Data is available upon request.
Cover illustration: Etienne Gilfillan

ISBN 978-1-912303-07-6 (hardback)
ISBN 978-1-912127-79-5 (paperback)
ISBN 978-1-912281-95-4 (e-book)

CONTENTS

WAYS IN TO THE TEXT

Who Is Alasdair MacIntyre? 9

What Does *After Virtue* Say? 10

Why Does *After Virtue* Matter? 12

SECTION 1: INFLUENCES

Module 1: The Author and the Historical Context 15

Module 2: Academic Context 20

Module 3: The Problem 25

Module 4: The Author's Contribution 30

SECTION 2: IDEAS

Module 5: Main Ideas 35

Module 6: Secondary Ideas 40

Module 7: Achievement 45

Module 8: Place in the Author's Work 50

SECTION 3: IMPACT

Module 9: The First Responses 56

Module 10: The Evolving Debate 61

Module 11: Impact and Influence Today 66

Module 12: Where Next? 71

Glossary of Terms 76

People Mentioned in the Text 82

Works Cited 90

THE MACAT LIBRARY

The Macat Library is a series of unique academic explorations of seminal works in the humanities and social sciences – books and papers that have had a significant and widely recognised impact on their disciplines. It has been created to serve as much more than just a summary of what lies between the covers of a great book. It illuminates and explores the influences on, ideas of, and impact of that book. Our goal is to offer a learning resource that encourages critical thinking and fosters a better, deeper understanding of important ideas.

Each publication is divided into three Sections: Influences, Ideas, and Impact. Each Section has four Modules. These explore every important facet of the work, and the responses to it.

This Section-Module structure makes a Macat Library book easy to use, but it has another important feature. Because each Macat book is written to the same format, it is possible (and encouraged!) to cross-reference multiple Macat books along the same lines of inquiry or research. This allows the reader to open up interesting interdisciplinary pathways.

To further aid your reading, lists of glossary terms and people mentioned are included at the end of this book (these are indicated by an asterisk [*] throughout) – as well as a list of works cited.

Macat has worked with the University of Cambridge to identify the elements of critical thinking and understand the ways in which six different skills combine to enable effective thinking.
Three allow us to fully understand a problem; three more give us the tools to solve it. Together, these six skills make up the **PACIER** model of critical thinking. They are:

ANALYSIS – understanding how an argument is built
EVALUATION – exploring the strengths and weaknesses of an argument
INTERPRETATION – understanding issues of meaning

CREATIVE THINKING – coming up with new ideas and fresh connections
PROBLEM-SOLVING – producing strong solutions
REASONING – creating strong arguments

To find out more, visit **WWW.MACAT.COM.**

CRITICAL THINKING AND *AFTER VIRTUE*

Primary critical thinking skill: EVALUATION
Secondary critical thinking skill: INTERPRETATION

Alasdair MacIntyre's 1981 *After Virtue* was a ground-breaking
contribution to modern moral philosophy. Dissatisfied with the major
trends in the moral philosophy of his time, MacIntyre argued that
modern moral discourse had no real rational basis. Instead, he
suggested, if one wanted to build a rational theory for morality and
moral actions, one would have to go all the way back to Aristotle.

To build his arguments – which are widely acknowledged to be as
important as they are complex – MacIntyre relies on two critical
thinking skills above all others: evaluation and interpretation. The
primary goal of evaluation is to judge the strength or weakness of
arguments, asking how acceptable a given line of reasoning is, and how
adequate it is to the situation. In *After Virtue*, MacIntyre applies incisive
evaluation skills to major positions and figures in moral philosophy one
after the other – showing how and why Aristotle's template remains a
stronger way of considering moral questions.

Throughout this process, MacIntyre also relies on his interpretative
skills. As MacIntyre knows, clarifying meanings, questioning
definitions, and laying down definitions of his key terms is as vital to
advancing his arguments as it is to evaluating those of other
philosophers.

ABOUT THE AUTHOR OF THE ORIGINAL WORK

Alasdair MacIntyre was born in 1929 in Glasgow, Scotland. Originally a Marxist, he later turned against communism, considering it a destructive ideology. MacIntyre championed the role of character in evaluating ethical behavior, developed by the Greek philosopher Aristotle (and known as Aristotelian virtues), and also idealized small local communities, pitting them against modern, capitalist societies. This was partly due to his part-rural Scottish, part-Irish family history. MacIntyre was an academic at several universities in the United Kingdom before moving to the United States in 1969 to continue his career.

ABOUT THE AUTHOR OF THE ANALYSIS

Jon Thompson teaches in the Department of Philosophy at King's College London, where he is currently a PhD candidate.

ABOUT MACAT

GREAT WORKS FOR CRITICAL THINKING

Macat is focused on making the ideas of the world's great thinkers accessible and comprehensible to everybody, everywhere, in ways that promote the development of enhanced critical thinking skills.

It works with leading academics from the world's top universities to produce new analyses that focus on the ideas and the impact of the most influential works ever written across a wide variety of academic disciplines. Each of the works that sit at the heart of its growing library is an enduring example of great thinking. But by setting them in context – and looking at the influences that shaped their authors, as well as the responses they provoked – Macat encourages readers to look at these classics and game-changers with fresh eyes. Readers learn to think, engage and challenge their ideas, rather than simply accepting them.

'Macat offers an amazing first-of-its-kind tool for interdisciplinary learning and research. Its focus on works that transformed their disciplines and its rigorous approach, drawing on the world's leading experts and educational institutions, opens up a world-class education to anyone.'

Andreas Schleicher
Director for Education and Skills, Organisation for Economic Co-operation and Development

'Macat is taking on some of the major challenges in university education ... They have drawn together a strong team of active academics who are producing teaching materials that are novel in the breadth of their approach.'

Prof Lord Broers,
former Vice-Chancellor of the University of Cambridge

'The Macat vision is exceptionally exciting. It focuses upon new modes of learning which analyse and explain seminal texts which have profoundly influenced world thinking and so social and economic development. It promotes the kind of critical thinking which is essential for any society and economy.
This is the learning of the future.'

Rt Hon Charles Clarke, former UK Secretary of State for Education

'The Macat analyses provide immediate access to the critical conversation surrounding the books that have shaped their respective discipline, which will make them an invaluable resource to all of those, students and teachers, working in the field.'

Professor William Tronzo, University of California at San Diego

WAYS IN TO THE TEXT

KEY POINTS

- Alasdair MacIntyre was born in Glasgow, but was raised and educated in the London area.
- *After Virtue* is one of the most important texts in bringing back the principles of virtue ethics* in moral philosophy.*
- *After Virtue* won the American Political Science Association's prestigious Benjamin E. Lippincott Award, and was the watershed publication in MacIntyre's prolific philosophical career.

Who Is Alasdair MacIntyre?

Alasdair MacIntyre was born in the city of Glasgow on January 12, 1929. His parents, both doctors, were from the rural west of Scotland. When he was a baby the family moved to England, where he grew up in the London area.

MacIntyre showed an early interest in the classics—that is, the literature and philosophy of Ancient Greece and Rome—and first graduated with a degree in the subject from Queen Mary College in London. He went on to study philosophy, earning an MA from Manchester University.

Committed to Gaelic* culture (that is, the culture of Celtic* Scotland and Ireland), he learned to speak the Scottish Gaelic language

from an aunt. Throughout his adult life he has been committed to the culture and politics of Ireland.

Although a Marxist* as a student, he later repudiated Marxist philosophy but remained critical of liberalism,* the political and economic philosophy that defines modern Western capitalism* and which he came to see as a destructive ideology. Instead he looked back to the concept of the virtues as described by the Ancient Greek philosopher Aristotle.*

From the late 1970s, this idea became fundamental to his thought and writing—a direction in his thinking that came to fruition with *After Virtue*, published in 1981. By this time he had been in the United States for over a decade, continuing the academic career he had begun in Britain with professorships at Boston, Vanderbilt, Brandeis, Notre Dame, and Duke universities. *After Virtue* is a work of moral philosophy—that is, it is concerned with the theory of moral thought and behavior.

MacIntyre's ideas were often controversial, at odds with the prevailing liberal philosophy of modern politics. His use of historicism*—an approach to moral philosophy that places an emphasis on the historical contexts in which philosophical arguments arise—was equally contentious. Nevertheless, his legacy is now well established and he has influenced philosophical, sociological,* and religious thinkers in the academic world and beyond.

What Does *After Virtue* Say?

After Virtue starts from the position that modern moral philosophy has failed to explain how people should live a good life. MacIntyre sees two main reasons for this.

First, he believes political philosophy* has become subject to relativism:* it is generally true, in other words, that no single system of philosophy or ethics is regarded as better than any other. Although this implies that people have no moral foundation in common,

philosophers and politicians (and, indeed, just about everyone else) continue to make statements and decisions they claim to be based on moral authority. But since there is no agreement about what the basis of this moral authority actually is, there is no coherence between the different views we hold.

In fact, moral judgment has been reduced, so MacIntyre believes, to little more than empty language based on manipulation. He calls the belief that moral claims can be reduced to emotional responses of approval or disapproval "the culture of emotivism."*

Second, MacIntyre believes the claim that there could be a universal approach to moral philosophy is false. He argues that it is not possible to find an approach to questions of morality that could give a definition of, say, justice, that would apply to all societies. This is contrary to the thought of scholars such as the American political philosopher John Rawls,* who believed that a universal approach to moral philosophy could be achieved by way of a "veil of ignorance," so that people could forget any possible self-interest and consider justice without bias.

For MacIntyre, such a veil of ignorance is impossible to achieve. To resolve this dilemma, he goes back to the thinking of Aristotle and his concepts of the virtues and moral and political practice. In *After Virtue*, MacIntyre's aim is to replace what he regarded as the dysfunctional system of moral philosophy with Aristotle's system of "virtue ethics": a tradition of ethical enquiry that emphasizes the importance of virtues (courage, prudence, temperance, and charity, for example) in the lives of those capable of acting with morality. For MacIntyre, virtue ethics brings with it a sense of underlying purpose and unity.

The work also addresses the failings of capitalism in a different way from the Marxist analysis he once subscribed to, by offering a structure for the moral good life as lived by the individual and the community. MacIntyre is a strong supporter of local communities. Ultimately, MacIntyre says, humans have a purpose: to live a good life within a

social community with others. This is an idea that clearly runs counter to the individualism endemic in much liberal thinking.

Thirty-five years after its original publication *After Virtue* has been reprinted several times, most recently (at the time of writing) in 2014. Translated into 15 foreign languages, it has been has been read far beyond the academic world, and is generally regarded as a seminal text for anyone studying political and moral philosophy.

MacIntyre is widely acclaimed. He was awarded the Benjamin E. Lippincott award by the American Political Science Association in 2011 and has been President of the American Philosophical Association.

Why Does *After Virtue* Matter?

Although he has written more than 30 books in his working life, *After Virtue* is generally regarded as Alasdair MacIntyre's most important and influential work. It offers a revolutionary perspective on the field of moral philosophy, attacking all of the field's major schools of thought: liberalism (founded on the rights, liberty, and equality of each individual), utilitarianism* (the philosophy that the "best" action offers the greatest "utility" for the greatest number of people) and deontology* (an approach to moral philosophy that emphasizes duty and moral obligation).

MacIntyre describes the failings in all of these ways of thinking and explains why, in his view, they have brought about the more general failure of contemporary moral philosophy. As such, it is a fine introduction to the conflicting points of view within modern moral and political philosophy. The solution that MacIntyre proposes to the problems he identifies is to reintroduce Aristotle's virtue ethics so that the debate can find some common ground.

His ideas have found application far beyond the field of moral philosophy, having been used to try to solve problems in the worlds of sociology, politics, finance, and religion. MacIntyre himself is not only

considered one of the world's most influential living moral philosophers, he continues to comment on world affairs; in 2010, for example, he gave a lecture in Cambridge on the causes of the 2008 global financial crisis. He remains a major influence on political thinking generally, and political thinkers continue to study his views on capitalism and globalization.

MacIntyre not only analyzes schools of thought within moral philosophy but adopts an equally stringent scrutiny to religions, notably Christianity, and to political ideologies such as Marxism. To all of the subjects he considers, he brings a broad sweep of history and a multi-disciplinary approach, from classical Greece to Shakespeare to Jane Austen, to the global financial markets and contemporary political maneuvers.

Reading MacIntyre does not simply offer us a particular way of thinking and conducting philosophical analysis; it provides an understanding of what has been considered worthwhile—what it means to live a good life—by creative minds over the centuries.

SECTION 1
INFLUENCES

MODULE 1
THE AUTHOR AND THE HISTORICAL CONTEXT

KEY POINTS

- The publication of *After Virtue*, reintroducing the idea of virtue ethics,* was a turning point in twentieth-century moral philosophy.*

- Alasdair MacIntyre has shown a life-long opposition to global capitalism.*

- The text was underpinned by the moral failures of Stalinism*—the repressive political philosophy of the Soviet* leader Joseph Stalin.*

Why Read This Text?

The philosopher Alasdair MacIntyre's *After Virtue* is perhaps the most significant book on virtue ethics—an approach to the study of ethics that emphasizes the importance of virtues such as temperance and justice—published in the twentieth century. In it, MacIntyre gives his analysis and criticism of the principle approaches to moral philosophy (the branch of philosophy that considers the theory and practice of morality and moral behavior). This analysis includes a critical discussion of the theory of utilitarianism* (according to which an action should be considered according to the benefit it brings) and deontology* (which emphasizes obligations and duty), among other schools of thought relevant to his thesis.

After Virtue calls for a return to traditional virtues—justice, prudence and courage—in the contemporary world. MacIntyre argues that this tradition, known as virtue ethics, is not only older than

> **❝** I had the philosophical good fortune to be educated in two antagonistic systems of belief and attitude. On the one hand ... [to] be just was to play one's assigned role in the life of one's local community. Each person's identity derived from the person's place in their community ... On the other hand ... I was taught ... to pass those examinations which are the threshold of bourgeois life in the modern world. **❞**
>
> Alasdair MacIntyre, "An Interview with Giovanna Borradori"

the systems of ethics that dominate modern thought but is also more capable of settling the moral disputes that characterize the modern world.

MacIntyre's arguments about the nature of a virtue, his description of the place of virtues within social and political life, and his critique of modern moral philosophy together constitute a coherent and appealing moral system. Any philosopher wanting to study virtue ethics—or even moral philosophy generally—must take the arguments of *After Virtue* into account.

After Virtue is interdisciplinary in nature (that is, it draws on the aims and methods of a variety of academic disciplines) and has influenced fields as diverse as moral philosophy, political philosophy,* international relations,* sociology,* and theology.* Although the text is useful for understanding these different ways of thinking, *After Virtue*'s principal aim is the promotion of an understanding of morality—both for the individual as well as wider Western culture.

Author's Life

Alasdair Chalmers MacIntyre was born in the Scottish city of Glasgow on January 12, 1929. His parents, John and Emily MacIntyre, came from a close-knit community and culture, and his early life was

characterized by a tension between this traditional family life and the liberal* modernity* of his formal education.[1] MacIntyre describes his family's cultural history as "a Gaelic* oral culture of farmers and fishermen, poets and storytellers"[2] (the Gaels are a people from the British Isles who spoke a Celtic language before the arrival of the Anglo-Saxon people from the northern European mainland). For him, he explains, the "modern world was a culture of theories rather than stories."[3]

Though MacIntyre was raised in London, and studied modern philosophy in the English city of Manchester, he also knew the Scots Gaelic language and traced his family roots back to small communities in Northern Ireland. He was, in other words, connected simultaneously to the world of Irish stories and communal life and to the theoretical concerns of modern philosophy. This tension, which informed MacIntyre's entire career, especially touched the development of his work from about 1981 onwards. Indeed, in *After Virtue* MacIntyre would idealize life within local communities in comparison to life in modern, capitalist societies.

MacIntyre earned Masters' degrees from the universities of Manchester and Oxford, and he lectured at Leeds, Essex, and Oxford universities in the United Kingdom. In 1969, he emigrated to the United States where he held academic positions for the remainder of his career, at Brandeis, Boston, Yale, Duke, Vanderbilt, Notre Dame and Princeton universities. In 2010, MacIntyre became Senior Research Fellow at London Metropolitan University's Centre for Contemporary Aristotelian Studies in Ethics and Politics. His success as a philosopher is attested by his tenure as president of the American Philosophy Association and his election to the prestigious American Philosophical Society, founded in 1785.

Author's Background

MacIntyre has held a range of philosophical convictions in the course

of his life. Interestingly, the Ancient Greek philosopher Aristotle* had argued for a moral system based upon the life of a small form of community called the *polis*, and this must have resonated with the small-scale culture of MacIntyre's Scottish ancestors. Indeed, MacIntyre's *After Virtue* reflects both his abstract, philosophical education and his communal Scottish lineage. This is because MacIntyre argues abstractly for the philosophical superiority of Aristotle's ethics, but he also argues that the outworking of Aristotle's philosophy must be realized in a small-scale community.

As a young man, he was a very active member of the British Marxist* movement and was for a time the editor of the Marxist journal *The New Reasoner*.[4] In the 1950s and 1960s—when MacIntyre was developing his philosophical career—Marxism was regarded as the primary alternative to a capitalist, liberal approach to social and moral problems. Eventually, however, he became disillusioned with Marxism due to the repression and atrocities carried out in the Soviet Union under its then-leader leader Joseph Stalin.*[5] These evils were problematic for MacIntyre because the Soviet Union claimed to derive its ideology from the same Marx whom MacIntyre had admired.

He later described his research for *After Virtue* as preoccupied "with the question of the basis for the moral rejection of Stalinism,"[6] having previously argued in his *Marxism and Christianity* that "[a] Communist who broke with his Party on account of such an [immoral] action … was and is peculiarly vulnerable to the [question] … 'What do you mean by "wrong"?'"[7] In other words, MacIntyre had previously thought that Marxism was a moral stance from which he could criticize the destructive consequences of capitalism. However, when Marxism proved to have immoral consequences in the Soviet Union, MacIntyre could find no alternative moral ground to stand on to condemn Marxism. MacIntyre therefore adopts an Aristotelian position in *After Virtue*—an approach that reflects his

abandonment of the Marxist theory that he had championed earlier in his career. Through Aristotle he found that he could make a judgment about the ethics of the political philosophy of Marxism.

During the period leading up to the publication of *After Virtue*, it appears that MacIntyre also rejected his original faith, Christianity, in favor of atheism*—the belief that there is no God or divine power. His atheism, however, was fleeting; MacIntyre later returned to Christianity, having described himself in 1988 as an "Augustinian Christian."[8] Indeed, he has said that belief in God, or theism,* is an implication of the Aristotelian virtue ethics expressed in *After Virtue*.[9]

NOTES

1 Kelvin Knight, "An Interview with Giovanna Borradori," in *The MacIntyre Reader*, ed. Kelvin Knight (Notre Dame, IN: University of Notre Dame Press, 1998), 255–66.

2 Knight, *The MacIntyre Reader*, 255.

3 Knight, *The MacIntyre Reader*, 255.

4 Alasdair MacIntyre, "Preface," *After Virtue* (London: Duckworth, 2007), xv.

5 Christopher Stephen Lutz, "A Short History of Alasdair MacIntyre," in *Tradition in the Ethics of Alasdair MacIntyre: Relativism, Thomism, and Philosophy* (Plymouth, UK: Lexington Books, 2009), 22–24.

6 MacIntyre, "Preface," *After Virtue*, xv.

7 Alasdair MacIntyre, *Marxism and Christianity* (New York: Schocken Books, 1968), 125.

8 Alasdair MacIntyre, *Whose Justice? Which Rationality?* (Notre Dame, IN: University of Notre Dame Press, 1988), 10.

9 MacIntyre, *Whose Justice? Which Rationality?*, 165–6.

MODULE 2
ACADEMIC CONTEXT

KEY POINTS

- Alasdair MacIntyre's *After Virtue* is primarily a work of moral philosophy*; it is concerned with the moral qualities that lead to right actions known as "virtues."
- Alasdair MacIntyre was part of a movement that rejected the political philosophies of utilitarianism,* deontology,* and liberalism* in favor of an emphasis on the virtues in ethics and politics.
- An understanding of the influence of Aristotelian* philosophy on *After Virtue* should help the reader to interpret the text.

The Work in its Context

Alasdair MacIntyre's *After Virtue* is a work of moral philosophy, a field that is primarily concerned with answering the question: What is the good life? As the American philosopher James Rachels* put it: "Moral philosophy is the attempt to achieve a systematic understanding of the nature of morality and what it requires of us—in Socrates's* words, of 'how we ought to live,' and why."[1]

Three main theories dominate moral philosophy today: deontology (or Kantian ethics*), utilitarianism, and virtue ethics.* Deontology, developed by the eighteenth-century German philosopher Immanuel Kant,* emphasizes duties; utilitarianism,* devised by the British philosopher Jeremy Bentham* and his student John Stuart Mill,* is the view that the consequences of an action are the only things that can make it right or wrong; virtue ethics date back to Ancient Greece and assert that ethics are primarily about acting in accordance with the virtues—moral qualities that lead to right actions.

> 66 Moral philosophy is the attempt to achieve a systematic understanding of the nature of morality and what it requires of us—in Socrates's words, of 'how we ought to live,' and why ... There are many rival theories, each expounding different conceptions of what it means to live morally, and any definition that goes beyond Socrates's simple formulation is bound to offend one or another of them. 99
>
> James Rachels, *The Elements of Moral Philosophy*

The related field of political philosophy* is concerned with such concepts as justice and freedom, and the authority of governing bodies. Political philosophy focuses on which rules, duties and virtues are best for guiding life as a group or state. Both fields are integrated in MacIntyre's argument in *After Virtue*, making it an interdisciplinary enterprise.

Overview of the Field

The Ancient Greek philosopher Aristotle is important for the understanding of *After Virtue*. In the fourth century B.C.E., he argued for a moral philosophy based on virtue. This moral philosophy, first of all, was connected with a teleological* concept of human nature— that is, it assumes that virtues exist for a purpose. According to Aristotle, the virtues help people realize a number of attributes and behaviors characteristic of human beings. The virtue of courage, for example, exists to help people defend themselves and their loved ones; the virtue of justice helps people solve disputes.

Aristotle's list of the most vital virtues includes temperance, prudence, courage, and justice. These virtues, however, are not merely a way of behaving well on occasion. They are deep, long-term aspects of the character of a well-functioning person. The point of the moral

life, according to this system, is not merely to do the right thing but also to become the kind of person for whom right actions are natural and performed for their own sake.

For Aristotle, politics were closely linked to an individual's moral quest because the virtues were necessary not only for the flourishing of the individual but for a useful participation in the *polis* (the city).[2] For example, although Aristotle saw prudence as an asset for the individual, it was also a necessary requirement in order to participate in the debates in the *agora* (marketplace) in Athens.

Academic Influences

The impact of Aristotle's account of virtues endured throughout the entire history of moral philosophy, maintaining its relevance until the period of history called the Enlightenment*[3] (roughly the mid-seventeenth century until the end of the eighteenth century), when rationality became an increasingly important component of European culture. By the twentieth century, Aristotle's virtue ethics had largely been superseded, replaced by deontology and utilitarianism as the main schools of moral thought.

Profound questions were raised about the state of moral philosophy, however, in the British philosopher Elizabeth Anscombe's* 1958 essay "Modern Moral Philosophy."[4] Anscombe's criticisms included the claim that moral "oughts" had no meaning in current moral discourse because they had been disconnected from the Christian tradition that saw morality as the rules of a divine lawgiver. Without the lawgiver, Anscombe argued, such "ought" statements were meaningless.

She also called for the restoration of the concept of a virtue, arguing that "the proof that an unjust man is a bad man would require a positive account of justice as a 'virtue.' This part of the subject-matter of ethics is, however, completely closed to us until we have an account of what *type of characteristic* a virtue is."[5] In other words, philosophers

had lost touch with Aristotle's virtues—or, at the very least, they had failed to make a case for virtues that was plausible in the twentieth century.

Anscombe's essay had a profound impact on MacIntyre's thinking in *After Virtue*. In fact, several of the arguments in *After Virtue* were an amplification of some of those found in "Modern Moral Philosophy."

In political philosophy, the decline of virtue ethics in the twentieth century resulted in discussions of justice based upon the German philosopher Immanuel Kant's* political philosophy and the English political theorist John Locke's* entitlement theory of justice. Kant had argued that an individual could understand justice by looking at society from a purely rational and unbiased standpoint. Locke held that human beings originally existed in a state of anarchy and that government had come into existence to provide order and protect private property.

In the twentieth century, Kant's view was re-stated in the influential moral philosopher John Rawls's* work *A Theory of Justice*,[6] and Locke's reappeared in the political philosopher Robert Nozick's* *Anarchy, State, and Utopia*.[7]

As a book of both moral and political philosophy, *After Virtue* engaged in both of these debates. MacIntyre agreed with Anscombe's criticisms of modern moral philosophy and so sought a renewed understanding of the concept of a "virtue," as well as the reason why it had been lost in modern philosophy. However, *After Virtue* also applied Anscombe's insights to the field of political philosophy, arguing that both Rawls and Nozick's accounts of justice fell short because they failed to give an account of justice as a virtue.[8]

MacIntyre's analysis of moral and political philosophy brought Aristotle's virtue ethics full circle and restored their relevance in the twentieth century

NOTES

1 James Rachels, *The Elements of Moral Philosophy, Fourth Edition* (New York: McGraw-Hill, 2003), 1.

2 Aristotle, *Nicomachean Ethics*, in *The Works of Aristotle*, vol. 4, trans. Thomas Taylor (Somerset, UK: Prometheus Trust, 2002), 428–32.

3 See Alasdair MacIntyre, *After Virtue* (London: Duckworth, 2007), 146–47.

4 Elizabeth Anscombe, "Modern Moral Philosophy," *Philosophy* 33, no. 124 (1958): 26–42.

5 Anscombe, "Modern Moral Philosophy," 29.

6 John Rawls, *A Theory of Justice*, revised edition (Oxford: Oxford University Press, 1999).

7 Robert Nozick, *Anarchy, State, and Utopia* (Oxford: Basil Blackwell, 1974), 183–204.

8 See MacIntyre, *After Virtue*, 244–55.

MODULE 3
THE PROBLEM

KEY POINTS

- MacIntyre was trying to understand if moral concepts such as justice could be understood as virtues or merely as procedural concepts, and why moral agreement was so difficult to achieve.

- The moral philosopher* John Rawls* argued that justice was essentially about equality, while the political philosopher* Robert Nozick* argued it was about entitlement; Elizabeth Anscombe* argued that it was a virtue.

- Alasdair MacIntyre followed Anscombe's view by developing the concept of a virtue and explaining why this was necessary for moral agreement.

Core Question

Alasdair MacIntyre's *After Virtue* was notably influenced by a problem framed by the British philosopher Elizabeth Anscombe. She argued that moral philosophy should be abandoned until it was revised in such a way that moral assertions would be meaningful. To Anscombe, concepts like "ought" and "obligation" were remnants of an earlier theory of ethics that no longer survived—they belonged to a morality that assumes either natural or divine law.[1] As a consequence, she wrote in 1958, "it is not profitable at present for us to do moral philosophy."[2]

The only way to understand such concepts, she proposed, was to revive the idea of virtue.[3] In the original context in which the word "justice" gained meaning, it was considered a virtue—a positive characteristic in an individual. If contemporary people ignored this aspect of its meaning, then it could not be the same concept that the

> 66 For the proof that an unjust man is a bad man would require a positive account of justice as a 'virtue.' This part of the subject-matter of ethics is, however, completely closed to us until we have an account of what *type of characteristic* a virtue is—a problem, not of ethics, but of conceptual analysis—and how it relates to the actions in which it is instanced. 99
>
> Elizabeth Anscombe, "Modern Moral Philosophy"

Greek philosophers Aristotle* and Plato* discussed. Anscombe's essay was a catalyst in the search for an understanding of moral "ought" statements and obligations, as well as the meaning of a virtue.

In the years after this publication, several prominent moral philosophers began to try to answer Anscombe's questions. Although MacIntyre took her arguments seriously, he posed a slightly different question. Instead of merely asking how to construct a coherent morality, he questioned why morality had become so incoherent in the first place. He argued that only by understanding how moral concepts had been lost could they be restored: the "form of [this] narrative," he stated, "the division into stages, presuppose standards of achievement and failure, of order and disorder."[4]

This historically grounded way of asking Anscombe's question about the state of modern moral philosophy was unique at the time.

The Participants

Two British philosophers, Peter Geach,* in his 1977 text *The Virtues*, and Philippa Foot,* in her 1978 book *Virtues and Vices*,[5] both defended some form of virtue ethics.* Each contributed important themes upon which *After Virtue* builds, including the link between factual claims and evaluative conclusions in the case of virtues and vices.

Geach, for instance, stated that virtues help people to function

better in the world, arguing that, "Men are benefited by virtues as bees are by having stings."[6] For instance, a firefighter needs courage to enter a burning building, and a teacher requires prudence in choosing a curriculum for her students. These are evaluative conclusions that follow from factual claims.

The American moral philosopher John Rawls took a different approach in establishing the nature of justice. In his *A Theory of Justice* (1971), he argued that someone could have access to the universal demands of justice if he could place himself behind the "veil of ignorance."[7] In other words, a person must imagine which principles of justice she would choose if she did not know which culture, religion, or class system she would inhabit in society.[8] Thus, Rawls argues for a concept of justice that supposedly transcends all cultures and times.

The Contemporary Debate

It seems MacIntyre regarded the debate about morality, on both the academic and popular levels, as one that could not be resolved. For instance, he points out that incompatible moral stances exist on issues like abortion, the redistribution of wealth, and the ethics of war.[9] But, more importantly, those with competing positions also have incompatible moral first principles. In *After Virtue*, MacIntyre calls this perennial disagreement "incommensurability."*[10] This incommensurability (the difficulty of resolving anything in the absence of any common system of measurement) is perhaps best understood in the context of the debate about justice between the followers of Rawls and those of the political philosopher Robert Nozick.

Rawls argued that justice was simply the principle of equal opportunity—that less advantaged individuals should not be denied opportunities for advancement due to poverty or sickness—while Nozick argued that the basic principle of justice is entitlement: that an

individual's justly acquired possessions should not be taken without consent.[11] If there is no rational way of judging between these principles, then Rawls and Nozick cannot come to an agreement about justice.

Many in this period doubted that Rawls's theory would suffice to achieve a standard of justice that could be universally agreed. This is principally because it is impossible to imagine how anyone could achieve the state of mind that would accommodate his veil of ignorance. MacIntyre admits that a person behind a veil of ignorance may perhaps choose Rawls's principles. But, he states, "*we* are *never* behind such a veil of ignorance."[12]

In short, though Rawls's idea sounds appealing, there is no possibility that a person, weighted by his or her social and religious ideas, can reach a standpoint of ignorance about his own position. So Rawls's method fails as a truly universal concept of justice. But MacIntyre's critique immediately raises another question: how can we argue for any specific definition of justice if a truly universal concept of justice is impossible? That is, if my account of justice is inherently tied to my social, religious, and personal background, then how, in a political context, can it extend to yours?

This conundrum is sometimes known as "the relativist challenge." MacIntyre's quest was to find an agreement about justice that neither accepted Rawls's universalist assumptions nor collapsed into relativism.

NOTES

1 Elizabeth Anscombe, "Modern Moral Philosophy," *Philosophy* 33, no. 124 (1958): 26.

2 Anscombe, "Modern Moral Philosophy," 26.

3 Anscombe, "Modern Moral Philosophy," 26.

4 Alasdair MacIntyre, *After Virtue* (London: Duckworth, 2007), 3.

5 Philippa Foot, *Virtues and Vices and Other Essays in Moral Philosophy* (Berkeley: University of California Press, 1978), 1–18.

6 Peter Geach, *The Virtues* (Cambridge: Cambridge University Press, 1977), VII.

7 John Rawls, *A Theory of Justice* (Oxford: Oxford University Press, 1999), 118.

8 Rawls, *A Theory of Justice*, 118–23.

9 MacIntyre, *After Virtue*, 6-7.

10 MacIntyre, *After Virtue*, 8.

11 Robert Nozick, *Anarchy, State, and Utopia* (Oxford: Basil Blackwell, 1974), 183–204.

12 MacIntyre, *After Virtue*, 249.

MODULE 4
THE AUTHOR'S CONTRIBUTION

KEY POINTS

- The failure to find agreement in modern moral philosophy* can be traced back to the abandonment of Aristotle's* virtue ethics* by Enlightenment* thinkers.

- *After Virtue* offers the most systematic explanation of the need for virtue ethics in modern moral philosophy.

- MacIntyre's immediate inspiration was the philosopher Elizabeth Anscombe,* but his moral philosophy is ultimately indebted to the Greek philosopher Aristotle's work *Nicomachean Ethics*.

Author's Aims

Alasdair MacIntyre, convinced that the twentieth century's usual ways of solving moral disagreement were deficient and that the result was a state of moral disarray, begins *After Virtue* with a thought experiment. He asks us to imagine a post-apocalyptic world in which all the scientists have been killed and the practice of science has been dismantled. People eventually pick up the pieces and attempt to recreate science. But, lacking any scientific knowledge, they carry out meaningless actions that only mimic it.

This scenario, contends MacIntyre, precisely describes what has happened to moral philosophy: there has been a total breakdown of moral language and practice in the modern world. MacIntyre concludes his first chapter by arguing that "the language and the appearances of morality persist even though the integral substance of morality has to a large degree been fragmented and then in part destroyed."[1] He is convinced that, though our culture still makes moral

> **66** The language and the appearances of morality persist even though the integral substance of morality has to a large degree been fragmented and then in part destroyed. **99**
>
> Alasdair MacIntyre, *After Virtue*

assertions and judgments, the systems that once held morality together have now fallen apart.

MacIntyre argues that the result of this breakdown (and the key problem of the modern moral world) is the embodiment of emotivism* in our culture—that is, the view that moral claims can be reduced to emotional responses of approval or disapproval. Although he does not think that everyone consciously accepts emotivism, the fact that debates in the modern moral world have no rational means of resolution (MacIntyre calls this "incommensurability"*) suggests that our culture is emotivist in practice.[2]

Approach

As outlined above, other philosophers had been aware of the problems with utilitarianism* (a philosophical approach to action that emphasizes potential benefit) and deontology* (a philosophical approach to action that emphasizes duty). MacIntyre, however, adopts an innovative methodology called historicism,* in which the moral philosopher studies the history of traditions of moral thought. Historicism also involves an investigation of the rivalry between particular moral traditions and the judgment of which might be superior.

MacIntyre's historicism was developed for two main reasons. The first was to explain how a moral system, like all other human phenomena, is part of a particular social life. MacIntyre claims that "[moral] concepts are embodied in and partially constitutive of forms

of social life."[3] In other words, ethical theories cannot be divorced from historical, political, and sociological* facts.

The second reason for historicism was the need to avoid both universalism* and relativism* in ethics (universalism is the assumption that one's own morality is absolute and relevant to everyone; relativism is the belief that no morality is better than any other). MacIntyre's method was intended to steer a careful course between these two extremes. He has always maintained that historicism is compatible with judging some ethical systems superior to others, believing that historical investigation, rather than mere abstract reasoning, is needed for such judgments. He describes historicism as the belief that "historical enquiry is required in order to establish what a particular point of view is, but also that it is in historical encounter that any given point of view establishes or fails to establish its rational superiority relative to its rivals in some specific contexts."[4]

Historical study, then, helps us to understand the strengths and weaknesses of moral systems and to judge between them. Our best understanding of ethics, however, must always be open to revision through comparison with other moral systems.

Contribution in Context

MacIntyre's historical approach connects to several debates in philosophy. It is, for example, meant to answer the dispute in the field of political philosophy between the moral philosopher John Rawls* and the political philosopher Robert Nozick.* Rawls and Nozick held fundamentally contradictory understandings of justice trapped in a state of "incommensurability"—that is, their positions could not be resolved.

Analyzing these positions, MacIntyre points to the ethics of taxation and healthcare. Person A holds that fairness demands equal opportunities for all. Since those opportunities cannot be pursued without basic medical care, others have an obligation to pay for

healthcare for those who cannot afford it.[5] Person B, on the other hand, holds that because we have a right to determine which financial obligations we commit to, we should not be coerced into funding someone else's healthcare through taxes.

The problem here is that the fundamental assumptions of Person A and Person B are incompatible. But, even worse, there appears to be no rational way of determining who is right. MacIntyre argues that "the rival premises are such that we possess no rational way of weighing the claims of one as against another."[6]

His historical approach seeks to expand the scope of moral philosophy and determine the rational superiority of one view over another. But it also addresses the question of why moral philosophy has become so disordered. According to MacIntyre, we have lost certain concepts we need to draw on if we are to avoid confusion in moral philosophy and disagreements such as that between Rawls and Nozick. It is only by recovering certain concepts from history that our thinking about moral philosophy can be fixed. So, for MacIntyre, a version of Aristotle's teleology*—an account of the purpose or function of human beings—must be revived in order to make sense of our moral concepts. This will make possible rational agreement on those questions that are now only characterized by "incommensurability."

NOTES

1 Alasdair MacIntyre, *After Virtue* (London: Duckworth, 2007), 5.

2 MacIntyre, *After Virtue*, 22.

3 Alasdair MacIntyre, *A Short History of Ethics*, 2nd edition (London: Routledge & Kegan Paul, 1998), 1.

4 MacIntyre, *After Virtue*, 269.

5 MacIntyre, *After Virtue*, 7.

6 MacIntyre, *After Virtue*, 8.

SECTION 2
IDEAS

MAIN IDEAS

KEY POINTS

- Citizens of the modern world can achieve meaningful moral and political discourse only if they adopt a moral framework that can make sense of what is good.

- The tradition of the virtues has been abandoned, thereby making moral statements meaningless and preventing moral and political agreement. The only way to recover moral meaning and achieve agreement is through an understanding of the virtues.

- MacIntyre presents his arguments in the form of grand historical narratives to show how moral philosophy* has splintered and lost its foundation.

Key Themes

Alasdair MacIntyre's *After Virtue* is a systematic diagnosis of the theory and practice of moral philosophy in the second half of the twentieth century. To understand the text it is worthwhile considering three themes.

First, MacIntyre argues that two factors—incommensurability* (the impossibility of resolving differences in the most basic moral positions) and emotivism* (the moral philosophical position that a moral judgment is nothing more than a statement of approval or disapproval) characterize modern moral philosophy and practice.[1]

The second theme addresses "the failure of the Enlightenment* project of justifying morality."[2] This "project" began in the eighteenth century during a time in European cultural history—the Enlightenment—characterized by a turn towards rationality.

> ❝ It was because a moral tradition of which Aristotle's thought was the intellectual core was repudiated during the transitions of the fifteenth to seventeenth centuries that the Enlightenment project of discovering new rational secular foundations for morality had to be undertaken. ❞
>
> Alasdair MacIntyre, *After Virtue*

Philosophers in this period were searching for a rational basis for morality that did not depend upon teleological* views of human beings (in other words, the Enlightenment philosophers did not want to assume that there was any inherent purpose, design or function for mankind).

The third principal theme in *After Virtue* is the return to resolving moral disagreements through the revival of Aristotle's* virtue ethics.*

Exploring the Ideas

In the first section of the book (chapters 1–3) MacIntyre presents modern moral philosophy as being in near total disarray.[3] Both moral claims and reasons and our everyday moral lives have been stripped of their former meaning and clarity by the dominance of emotivism.[4] MacIntyre admits that most people do not endorse emotivism but, because they make moral claims that cannot be rationally justified, "emotivism is embodied in our culture."[5] Emotivism in practice causes moral disagreements to end in shouting matches rather than rational agreement.

Why should we be convinced by MacIntyre's claim that our culture's moral philosophy is in a state of disarray and incoherence? One objection to *After Virtue* is that MacIntyre does not give sufficient evidence for this claim. However, he does point to the fact that people across a range of backgrounds continue to make moral assertions without any belief in a rational method of coming to an agreement.

After establishing this moral incoherence, MacIntyre turns his attention to its historical causes. "The Enlightenment project" is MacIntyre's name for the endeavor—spanning several centuries, nations and philosophical schools—to justify traditional morality. Its failure resulted in our society's current moral incoherence. MacIntyre cites three specific thinkers who approached this project from varying points of view. The eighteenth-century British philosopher David Hume* believed that human sentiments were the basis of moral philosophy. Conversely, the German philosopher Immanuel Kant* sought to ground morality solely in human reason, while the Danish philosopher Søren Kierkegaard* claimed that morality could be grounded in the will of the individual.[6]

MacIntyre claims that these attempts share one essential feature: their denial of a teleological conception of human nature, according to which human nature is decided and defined by certain purposes or functions in our behavior. Teleology had provided the backdrop for debates on moral philosophy for nearly 2,000 years[7] and dated back to Aristotle. When Enlightenment thinkers denied teleology, they were obliged to search for other reasons that might serve to justify morality.

The final major theme of *After Virtue* is MacIntyre's argument that Aristotle's virtue ethics give a much-needed framework and a rational foundation for moral claims. If you do not accept the idea of underlying purpose that is part of Aristotle's view, an inevitable gap opens up between the facts about human beings and the moral values they espouse. As David Hume famously observed, there is no way to move from the factual "is" to the moral "ought." People who make moral claims move seamlessly from supposed factual claims ("God commands you to honor your parents") to moral claims ("You ought to honor your parents"). Hume claims that such moves are false.[8] For MacIntyre, the practical acceptance of emotivism relies historically on the failure to resolve this problem, and he argues instead for the superiority of the Aristotelian tradition of virtue ethics.

MacIntyre, then, bases his argument on the idea that we can reclaim the teleology Aristotle had argued for, with certain qualifications—where Aristotle had understood the purposes of teleology to be biological, for MacIntyre the virtues were needed to fulfill social and community roles.[9] If this is the case, then it was premature for Enlightenment philosophy to abandon a version of Aristotle's teleology.

Language and Expression

MacIntyre's writing can sometimes be difficult to understand. He writes in the form of grand historical narratives, and it often takes several readings to understand his arguments fully.

For instance: he includes a chapter on "The Character of Generalizations in Social Science and their Lack of Predictive Power" beside a historical analysis from 3,000 years of Western philosophy. Although these sections at first seem unrelated to his subject, MacIntyre has his reasons for including them. The chapter on social sciences is there because he believes every moral philosophy includes some form of sociology.* So, if you regard human society as a machine that works in a particular way, this will affect the way you view questions about right and wrong behavior. Specifically, mechanistic views of debate and discussion will likely result in the introduction of certain social "inputs" that are designed to achieve the desired "outputs." A mechanistic understanding of society, according to which religion is dangerous, for example, might use school lessons or public advertising to weaken people's belief in religion.

MacIntyre's historical arguments are connected to his broader thesis. He believes history is central to moral philosophy, given that moral concepts come about through historical and social development. So, if we are to understand the meaning of a moral concept, we must understand the social context in which it arises. This is a stark break from most modern moral philosophy.

NOTES

1 Alasdair MacIntyre, *After Virtue* (London: Duckworth, 2007), 11.

2 MacIntyre, *After Virtue* 51–61.

3 MacIntyre, *After Virtue*, 2.

4 MacIntyre, *After Virtue*, 22.

5 MacIntyre, *After Virtue*, 22.

6 MacIntyre, *After Virtue*, 36–50.

7 MacIntyre, *After Virtue*, 54–61.

8 For Hume's discussion of the is/ought distinction, see David Hume, *A Treatise of Human Nature*, ed. L.A. Selby-Bigge and P.H. Nidditch, 2nd ed. (Oxford: Oxford University Press, 1978), 469–70.

9 MacIntyre, *After Virtue*, 196–7.

MODULE 6
SECONDARY IDEAS

KEY POINTS

- All moral and political arguments are made from the standpoint of a tradition and context. The narrative unity of a human life forms part of a coherent moral tradition and sees a life as a unique story rather than a random accumulation of events.

- MacIntyre's concept of a tradition has informed the fields of theology* (roughly, the systemized theory of religious belief) and Christian ethics, both Protestant* and Roman Catholic.*

- Chapter 17 of *After Virtue*, "Justice as a Virtue: Changing Conceptions," is one of the more influential sections of the text, helping shape political theory in the 1980s and 1990s.

Other Ideas

Several key ideas underpin Alasdair MacIntyre's argument in *After Virtue*. The first of these is his concept of a *practice*, meaning such activities as soldiering or nursing: a complex form of activity with its own set of "internal goods."[1] These "internal goods" form an intrinsic part of what makes the practice worthwhile. In contrast, "external goods" can be achieved without engaging in that particular practice. So, hitting home runs would be an internal good to baseball; making money would be an external good.

Related to MacIntyre's concept of practices is his understanding of a virtue: a developed characteristic that enables a human being to achieve those goods that are internal to practices. Courage in a soldier, or compassion in a nurse, for example, is vital if their practice is to be successful.

> ❝ In what does the unity of an individual life consist?
> The answer is that its unity is the unity of a narrative
> embodied in a single life. To ask 'What is the good for
> me?' is to ask how best I might live out that unity and
> bring it to completion. To ask 'What is the good for
> man?' is to ask what all answers to the former question
> must have in common. ❞
>
> Alasdair MacIntyre, *After Virtue*

Finally, MacIntyre's concept of a tradition of moral enquiry is important in his overall argument. He believes that moral claims and arguments are intrinsically tied to certain historical, social, and political conditions—in other words, to understand and analyze moral claims, we must understand their context.

Exploring the Ideas

As we have seen, MacIntyre revives Aristotle's* teleology*: the idea that what constitutes you, morally speaking, exists so that you can achieve some eventual end. For MacIntyre, however, this teleology is a matter of society and not biology, as Aristotle understood it.[2]

Aristotle had famously argued that human biology had built-in purposes and that this formed the basis of evaluative judgments about humans. In Aristotle's view, as a plant requires sun and water in order to grow and reproduce, so humans need the virtues in order to flourish. MacIntyre's interpretation, however, rests upon the concept of a "practice." "[A practice is] any coherent and complex form of socially established cooperative human activity though which goods internal to that form of activity are realized in the course of trying to achieve those standards of excellence which are appropriate to, and partially definitive of, that form of activity, with the result that human powers to achieve excellence, and human conceptions of the ends and

goods involved, are systematically extended."[3] Baseball and architecture are practices because they involve a set of internal goods. Successfully maximizing profits or driving a car, for example, do not—and so do not count as practices.

For MacIntyre, practices are, in part, defined by their "socially teleological nature":[4] there are certain desirable results within any form of social activity and, therefore, there are ways to evaluate them. To use one of MacIntyre's examples, the practice of farming includes attaining high crop yields and conserving the land. So it is logical to call someone who achieves these aims a "good farmer."[5]

How, then, do virtues fit into MacIntyre's account of practices? MacIntyre defines a virtue as "an acquired human quality the possession and exercise of which tends to enable us to achieve those goods which are internal to practices and the lack of which effectively prevents us from achieving any such goods."[6] In other words, virtues are crucial because they are the traits that allow us to achieve success in the many practices or activities that we engage in all the time.

In addition, MacIntyre's notion of "the narrative unity of a human life"[7] (seeing one's life as a unique story, rather than a mere accumulation of events) is important to an understanding of the arguments he makes. Indeed, the idea of conceiving of one's life as a meaningful whole rather than a series of unconnected actions, feelings, and events is vital to MacIntyre's moral philosophy. He argues that, in order for the virtues to guide you, you must be able to think of yourself as a "self whose unity resides in the unity of a narrative which links birth to life to death as narrative beginning to middle to end."[8] That is, all of your actions take place within an overarching life story. This is important because you only possess a virtue if you have a disposition to act virtuously across time.

Given that MacIntyre criticizes or advocates particular ethical systems, the concept of a tradition of moral enquiry is also important for MacIntyre's argument in the text. Utilitarianism,* deontology*

and Aristotelian virtue ethics* all count as traditions, having arisen at certain historical points as the expressions of certain social and political factors. MacIntyre defines a tradition as a "historically extended, socially embodied argument, and an argument precisely in part about the goods which constitute that tradition."[9] He claims that there is no such thing as "*morality-as-such*."[10] Thinking of morality in terms of traditions allows MacIntyre to group together certain sets of moral claims and to consider them sociologically* (that is, in the light of sociology: the study of the history and operations of society). He then evaluates them based on the success of these wider considerations.

Overlooked

The extent to which *After Virtue* could influence fields such as sociology has been somewhat overlooked. MacIntyre claimed that modern social science is based on a misguided philosophy derived from Thomas Hobbes's* belief in the universal laws of human nature. Contemporary sociology would no longer search for such sweeping generalizations. However, sociology as a discipline was founded on a denial of the Aristotelian view of human nature, which explained it in terms of achieving good for human beings through practical reasoning.

The sociologist Donald Levine* suggests that MacIntyre's argument in *After Virtue* has radical implications for social science because MacIntyre argues so convincingly for the pre-Hobbesian view of human behavior. Levine claims that social scientists have often ignored this entire field of enquiry and must gain "an Aristotelian ... vision: one that seeks to identify the social and cultural functions proper to particular historical settings, to delineate the external resources and internal practices needed to realize them, and to show ways of establishing conditions that ... sustain the quest for the good."[11] This Aristotelian sociological agenda represents a possible development for an often–overlooked aspect of *After Virtue*.

NOTES

1 Alasdair MacIntyre, *After Virtue* (London: Duckworth, 2007), 187.

2 MacIntyre, *After Virtue*,196–7.

3 MacIntyre, *After Virtue*, 187.

4 MacIntyre, *After Virtue*, 197.

5 MacIntyre, *After Virtue*, 56–8.

6 MacIntyre, *After Virtue*, 191.

7 MacIntyre, *After Virtue*, 204–25.

8 MacIntyre, *After Virtue,* 205.

9 MacIntyre, *After Virtue*, 222.

10 MacIntyre, *After Virtue*, 266.

11 Donald N. Levine, "Review: Sociology After MacIntyre," *American Journal of Sociology* 89, no. 3 (1983): 700–7.

MODULE 7
ACHIEVEMENT

KEY POINTS

- MacIntyre has given a significant amount of moral self-understanding both to philosophers and ordinary people.

- This came about as a result of his identification of the historical roots of some of our culture's deepest moral and conceptual problems.

- MacIntyre's sweeping arguments will persuade those who are already sympathetic, but they are too general to persuade those who require more detailed analysis.

Assessing the Argument

Due to its complex and interdisciplinary nature, Alasdair MacIntyre's *After Virtue* seems at first to complicate, rather than explain, the problems of modern moral philosophy.* MacIntyre set out to describe the history behind modern moral philosophy's lack of coherence and agreement, and also to provide a new, meaningful moral system. So the work had to include the fields of history, sociology,* and politics, as well as philosophy.

"It is both a strength and a weakness of *After Virtue* that in writing it I had two overriding preoccupations: both to set out the overall structure of a single complex thesis about the place of the virtues in human life … and to do so in a way that made clear how my thesis was incompatible with the conventional academic disciplinary boundaries."[1]

MacIntyre achieved his goals. His analysis of the history of the virtues, for instance, is far-reaching and bold. He begins with the Homeric age* of Greece, stretches through the Middle Ages,* and

> **66** It is both a strength and a weakness of After Virtue that in writing it I had two overriding preoccupations: both to set out the overall structure of a single complex thesis about the place of the virtues in human life ... and to do so in a way that made clear how my thesis was incompatible with the conventional academic disciplinary boundaries. **99**
>
> Alasdair MacIntyre, *After Virtue*

ends with an account of the virtues of the English novelist Jane Austen.*

MacIntyre outlines both the ways in which the virtues have changed in Western philosophy and how they have remained essential; he analyses sociological ideas such as generalizing "laws" in the social sciences; he critiques attempts to predict human behavior—at both the individual and societal level—which encourage us to view each other as means rather than ends in themselves (in other words, the sociological assumptions of those who would use human beings to achieve external goals, rather than treating them with dignity and respect); finally, he connects his moral theory to the most popular— and contentious—political questions of his day, such as the redistribution of wealth through state welfare. He considers the loss of moral coherence in our culture, and argues for a revised version of Aristotle's* virtues—one based on social practices.

Achievement in Context

A surge of interest in political philosophy* occurred in the 1970s and 1980s, largely due to the publication of John Rawls's* hugely influential *A Theory of Justice* in 1971.[2] Rawls argued for a concept of justice that was in some sense universal, one in which just principles

would be decided by those who were behind a "veil of ignorance" and so unaffected by any consideration of personal advantages or disadvantages.[3] MacIntyre flatly contradicted such a project, arguing that "*we* are *never* behind such a veil of ignorance."[4]

In many ways, MacIntyre's contradiction of Rawls's popular views helped create momentum for the political arguments made in *After Virtue*. Other philosophers agreed with MacIntyre that it was not possible to reach an absolutely objective and universal conception of justice.[5] Many also agreed with his claim that liberalism* fails to supply a coherent account of the ultimate good for human beings.

This group, which criticizes liberalism's refusal to address the question of the ultimate good, is often called communitarianism.* Despite the contribution that MacIntyre's work made to the movement, he has always denied the title of communitarian. Though he believes communitarianism is right to seek a shared understanding of the good, he thinks it is wrong to seek to put that understanding into action through the machine of the modern nation-state. However, this initial influence has meant most people know more about MacIntyre's arguments against Rawls rather than his moral philosophy as a whole.

Limitations

Alasdair MacIntyre acknowledges in the prologue to the third edition (2007) of *After Virtue* that the book was written for a non-academic as well as an academic audience.[6] In the preface to *Whose Justice? Which Rationality?* (1988) he reaffirms that both this work and *After Virtue* were written for a mixed readership.[7] This approach was quite deliberate. Part of MacIntyre's critique of modernity* (roughly, the cultural assumptions that emerged from the Enlightenment*) is that the professionalization of the philosopher has resulted in a host of social and moral problems. Thinking about the good life has become the province of a select few—but it is a debate that should concern us

all. According to MacIntyre, the philosopher's ultimate goal should be contributing to the social and moral life of the community.

MacIntyre's view of his own role as a philosopher made *After Virtue* accessible and the book has appealed to popular and academic audiences around the world. MacIntyre claimed that, some 25 years after publication, he had had "[c]ritical and constructive discussion in a wide range of languages—not only in English, Danish, Polish, Spanish, Portuguese, French, German, Italian, and Turkish, but also Chinese and Japanese."[8]

In addition to *After Virtue*'s relative success in reaching a popular audience, some major figures in academic moral philosophy have been deeply affected by the text's sweeping argument. Among these are the British philosophy scholar Kelvin Knight* and Rosalind Hursthouse,* professor of philosophy at the University of Auckland, in New Zealand. Many less well-known scholars from Europe, Colombia, China, and Tasmania have also discussed the text, along with MacIntyre's later writings.[9]

While this demonstrates the worldwide scholarly interest in *After Virtue*, some moral philosophers regard the book's only importance as historical.[10] MacIntyre's historicist* methodology, emphasizing the historical context of the moral traditions he discusses, might therefore represent one of *After Virtue*'s starkest limitations. And many philosophers, unwilling to reconsider their entire method of moral philosophy, did not want to engage with the arguments proposed in the work.

It must also be acknowledged that the book's density might deter some readers. As the American scholar Stanley Hauerwas* has commented, many will be discouraged when they realize that they might miss many of MacIntyre's arguments if they haven't read as broadly as MacIntyre himself had.[11]

NOTES

1 Alasdair MacIntyre, *After Virtue* (London: Duckworth, 2007), 264.

2 See John Rawls, *A Theory of Justice*, revised ed. (Oxford: Oxford University Press,1999).

3 Rawls, *A Theory of Justice*, 118.

4 MacIntyre, *After Virtue*, 249.

5 Will Kymlicka, "Community" in *A Companion to Contemporary Political Philosophy*, ed. Robert E. Goodin and Philip Pettit (Oxford: Blackwell, 1993), 366–78; see also Daniel Bell, "Communitarianism," in *The Stanford Encyclopedia of Philosophy* (Spring 2012 edition), ed. Edward N. Zalta, accessed October 22, 2013, http://plato.stanford.edu/archives/spr2012/entries/communitarianism/.

6 MacIntyre, "Prologue to the Third Edition," *After Virtue*, xiii.

7 Alasdair MacIntyre, "Preface," *Whose Justice? Which Rationality?* (Notre Dame, IN: University of Notre Dame Press, 1988), x.

8 MacIntyre, "Prologue to the Third Edition," *After Virtue*, vii.

9 Website for Contemporary Aristotelian Studies in Ethics and Politics, accessed February 27, 2015, https://metranet.londonmet.ac.uk/depts/lgir/research-centres/casep/staff/rest-of the-world.cfm.

10 See David Baggett and Jerry L. Walls, *Good God: The Theistic Foundations of Morality* (Oxford: Oxford University Press, 2011), 109.

11 Stanley Hauerwas, "The Virtues of Alasdair MacIntyre," *First Things* (October 2007), accessed October 22, 2013, http://www.firstthings.com/article/2007/09/004-the-virtues-of-alasdair-macintyre-6.

MODULE 8
PLACE IN THE AUTHOR'S WORK

KEY POINTS

- *After Virtue* shared the historical approach to moral philosophy* of Alasdair MacIntyre's previous works, but placed more emphasis on virtue ethics.*

- *After Virtue*'s moral enquiry emphasized the virtue ethics of the Greek philosopher Aristotle* and this enquiry, continued in MacIntyre's later works, established his reputation.

- MacIntyre went on to further defend and develop the arguments of *After Virtue* in the follow-up, *Whose Justice? Which Rationality?*

Positioning

Before the publication of *After Virtue* in 1981, Alasdair MacIntyre had focused on issues in Marxism* and its relationship to philosophy. His first book was *Marxism: an Interpretation* (1953), in which he was critical of the structures of the modern capitalist* system, and in 1968 he published *Marxism and Christianity*. Although, by this time, he had become disillusioned with both schools of thought, his concern for the plight of the disadvantaged and his criticism of the inequality of wealth continued.

His *A Short History of Ethics* (1966) revealed that MacIntyre had become sympathetic to some form of existentialism.* That is, he had come to believe that there was no rational basis for choosing one moral system over another. Adopting any particular moral framework was essentially a matter for the individual, and the belief that any moral system was absolute was both misguided and dangerous.[1]

A Short History of Ethics also laid the foundation for MacIntyre's

> ❝ [Taken together] *After Virtue, Whose Justice? Which Rationality?* and *Three Rival Versions of Moral Enquiry*... constitute an enormously ambitious and challenging undertaking comprising an extended and powerful critique of the perceived ills of modernity, including modern moral philosophy and political theory, and some radical and highly controversial suggestions as to how those ills might be remedied. ❞
>
> John Horton and Susan Mendus, "Alasdair MacIntyre, *After Virtue* and After"

historicist* approach, which would run through all of his later works of moral philosophy. In *A Short History*, he argues: "Moral concepts are embodied in and are partially constitutive of forms of social life. One key way in which we may identify one form of social life as distinct from another is by identifying differences in moral concepts."[2]

This statement closely anticipates MacIntyre's later claims in *After Virtue* that there is no single, unified concept of justice about which moral philosophers can debate.[3]

Integration

After Virtue arguably marked the beginning of MacIntyre's most significant intellectual period. Followed by the influential texts *Whose Justice? Which Rationality?* (1988), *Three Rival Theories of Moral Enquiry* (1990), and *Dependent, Rational Animals* (1999), the book marked a shift from the Marxist or existentialist[4] works that preceded it.

Although *After Virtue* fits with the rest of MacIntyre's mature works in its assertion that virtue ethics is the most viable moral philosophy, and the assumption that Aristotle is the figurehead for the tradition of the virtues, it differs from the mature works in some

respects. Between *After Virtue* and *Whose Justice? Which Rationality?* MacIntyre became convinced that Thomas Aquinas,* a religious scholar of thirteenth-century Italy, was an even better and more consistent exponent of the virtues than Aristotle:"I became a Thomist after writing *After Virtue* in part because I became convinced that Aquinas was in some respects a better Aristotelian than Aristotle, that not only was he an excellent interpreter of Aristotle's texts, but that he had been able to extend and deepen both Aristotle's metaphysical and his moral enquiries."[5] This shift can be seen in *Whose Justice? Which Rationality?* where MacIntyre's focus moves to the explanation and defense of the moral philosophy of Thomas Aquinas rather than that of Aristotle.

Another change in MacIntyre's viewpoint was his shift from the conviction that virtues can be explained according to principles of teleology*—that is, his move away from the idea that virtues are necessary so they can make some specific social end possible.

In *After Virtue*, MacIntyre argues that his account is more plausible because it does not depend upon Aristotle's "metaphysical biology"* (the argument that human biology, like the virtues, is defined by the purposes "built in" to it). Later, though, he became convinced that a full explanation of the virtues did indeed require an understanding of human biology.

This change in his thinking is clear in his most recent major work, *Dependent, Rational Animals*, in which he states "Rereading Aquinas … directed me towards resources that he provides for an account of the virtues that reckoned not only with our animal condition, but also with the need to acknowledge our consequent vulnerability and dependence."[6] Aquinas's writings led MacIntyre to consider how our animal nature makes us dependent upon others. This idea of dependence added to MacIntyre's work in explaining how human beings come to develop the virtues.

Significance

After Virtue, the book that established MacIntyre's reputation, is the most influential of his works. As Rosalind Hursthouse,* a moral philosopher from New Zealand, points out, it was one of the key texts in the revival of virtue ethics in modern moral philosophy.[7] Since its publication, MacIntyre's work has continued on much the same path. He has, for instance, maintained his criticism of liberal* political theory and global capitalism.[8] The political philosophy* scholars John Horton* and Susan Mendus* see MacIntyre's challenges to the modern world as substantial: "*After Virtue, Whose Justice? Which Rationality?* and *Three Rival Versions of Moral Enquiry.* Taken together … they constitute an enormously ambitious and challenging undertaking comprising an extended and powerful critique of the perceived ills of modernity, including modern moral philosophy and political theory, and some radical and highly controversial suggestions as to how those ills might be remedied."[9]

MacIntyre's criticisms in *After Virtue* are perhaps even more relevant some 35 years after the work's publication, as the global financial system has seen several destructive recessions—especially in 2000 and 2008. These financial crises have caused some to reconsider MacIntyre's wide-ranging criticisms of an economy based on interest, as well as the radically unequal distribution of wealth worldwide.[10]

MacIntyre's impact as a thinker is still noteworthy, as evidenced by his receipt in 2011 of the American Political Science Association's Benjamin E. Lippincott Award for a work of "exceptional quality" by a living political theorist still considered "significant" at least 15 years after its publication. *After Virtue* has maintained its popularity long enough to merit a fourth edition, published in 2014.

NOTES

1 Alasdair MacIntyre, *A Short History of Ethics* (London: Routledge, Kegan and Paul, 1967), 268–69.

2 MacIntyre, *A Short History of Ethics*, 1.

3 See Alasdair MacIntyre, *After Virtue* (London: Duckworth, 2007), 265–66.

4 MacIntyre, *A Short History of Ethics*, 268–69.

5 MacIntyre, "Prologue to the Third Edition," *After Virtue*, x.

6 Alasdair MacIntyre, "Preface," *Dependent, Rational Animals* (London: Duckworth, 1999), xi.

7 Rosalind Hursthouse, *On Virtue Ethics* (Oxford: Oxford University Press, 1999), 3.

8 John Cornwell, "MacIntyre on Money," *Prospect* (October 20, 2010), accessed October 22, 2013, http://www.prospectmagazine.co.uk/magazine/alasdair-macintyre-on-money/#.UmZvjpTwKrM.

9 John Horton and Susan Mendus, eds, *After MacIntyre: Critical Perspectives on the Work of Alasdair MacIntyre* (Cambridge: Polity Press, 1994).

10 Cornwell, "MacIntyre on Money," *Prospect*.

SECTION 3
IMPACT

THE FIRST RESPONSES

KEY POINTS

- MacIntyre's methodology was of significance to *After Virtue*'s reception.
- His methods were initially criticized as leading both to moral relativism* and an exclusion of minorities from political life due to his emphasis on the politics of small communities.
- MacIntyre rebutted the charge of relativism and claimed that small forms of community are less prone to oppression than the modern bureaucratic state.

Criticism

Alasdair MacIntyre's *After Virtue* received a great deal of attention in the years immediately after its publication, the responses ranging from acclaim to profound criticism.

One response to the book was to seek to integrate the virtues and moral development into other ethical theories. The British philosopher Onora O'Neill,* for instance, sought to incorporate the virtues into a moral philosophy* that owed a significant amount to the eighteenth-century German philosopher Immanuel Kant.[1] So MacIntyre certainly played a role in harmonizing the virtues with a range of broader moral theories.[2]

Critical responses included the claim that MacIntyre's system inevitably collapsed into relativism (the position that no moral claim is any better than any other), as the American ethical scholar Robert Wachbroit,* for instance, argued in his 1983 article, "A Genealogy of Virtues."[3]

> 66 What bothers me is not distinguishing [history from philosophy] or giving the impression that a historical enquiry can establish a philosophical point, as MacIntyre seems to do. 99
>
> William K. Frankena, *Ethics*

Meanwhile, the philosopher Stephen Mulhall* argued that MacIntyre was wrong in his view that the moral and political systems of the modern world were incoherent. Mulhall claimed that there was internal tension in MacIntyre's own analysis, rather than in political liberalism.* "[MacIntyre] wishes simultaneously to argue that liberal individualism is dominant, that our culture is thoroughly emotivist,* and that the conceptual resources of liberal individualism are incapable of accounting for the possibility of human agency and rational moral argument. Such a combination of claims is inherently unstable, for it amounts to arguing that the pervasive and dominant morality is logically incapable of functioning as a morality at all."[4]

If Mulhall's criticism is correct, then MacIntyre's reason for returning to the virtue ethics* tradition would be undermined.

Responses

MacIntyre engages in a wide-ranging dialogue with his critics and in his "Postscript to the Second Edition,"[5] he responds to many of their comments. On the charge of relativism, he writes that the moral philosopher must determine which tradition of moral enquiry is able to "identify and transcend the limitations of its rival or rivals."[6] He puts forward a case in which a certain tradition of moral enquiry cannot speak to or solve its own deep moral and conceptual problems—but another tradition can. To illustrate this, MacIntyre uses an analogy from the physical sciences.[7] He suggests that many observable physical phenomena can be explained with equal success

by the "impetus" physics of the Greek philosopher Aristotle* or the "mechanistic" physics of the British physicist Isaac Newton.* The Newtonian model succeeded, however, not only because it could understand and solve its own problems but because it could understand and solve the problems that arose within the Aristotelian model.

The same holds true, MacIntyre claims, for moral philosophy: "It is in the ability of one particular moral-philosophy-articulating-the-claims-of-a-particular-morality to identify and to transcend the limitations of its rival or rivals … that the rational superiority of that particular moral philosophy … emerges."[8] So, to succeed in his argument in support of the Aristotelian virtue tradition, MacIntyre had to show that it both understood and resolved the problems of the Enlightenment* and emotivist* moral traditions better than those traditions themselves.

MacIntyre also responds to several criticisms in his "Partial Response to My Critics" in *After MacIntyre*, edited by John Horton* and Susan Mendus.*[9] On Mulhall's claim that the moral systems of the modern world are not incoherent, MacIntyre counters that the moralities of liberalism can function, in a sense—just not as coherent moralities.[10] Although he does not spell out precisely what he means, MacIntyre seems to be alluding to the incoherence of the liberal conceptions of the human person and of the human good. Liberalism, he writes, "has become the kind of social and cultural tradition in which incoherence … is at home."[11] In other words, liberalism does not require any agreement on what constitutes the good for human beings—believing this to be good in itself.

Conflict and Consensus

MacIntyre still stands firm on his essential claims in *After Virtue*. In 2007, nearly 30 years after its first publication, he wrote, "I have as yet found no reason for abandoning the major contentions of *After Virtue*."[12] However, it is clear that some of MacIntyre's claims were not

sufficiently backed up in his original book and he acknowledged that he was unclear about how the historicist* method, in which different ethical systems are weighed in the light of their historical context, could resolve what are regarded as incommensurable* moral positions.

He expanded on his position[13] in the second edition (published 1984), and developed his study of the relationship between traditions of moral enquiry in his later books, notably *Whose Justice? Which Rationality?* In this work MacIntyre writes that "standards of rational justification themselves emerge from and are part of a history in which they are vindicated by the way in which they transcend the limitations of and provide remedies for the defects of their predecessors within the history of that same tradition."[14] That is, every moral tradition possesses its own first principles and so cannot simply persuade members of other traditions of its claims. It is only when a school of thought is able to understand and transcend the problems within other traditions that it wins the day.

Similarly, in response to critics who argued that MacIntyre had renounced "a morality of rules,"[15] MacIntyre later re-affirmed that "virtue ethics" did not represent the totality of his moral system: "a morality of law" must complement an ethics of virtue.[16]

NOTES

1 Onora O'Neill, "Kant After Virtue," *Inquiry,* 26, no. 4 (1983): 387–405.

2 Martha Nussbaum, "Virtue Ethics: A Misleading Category?" *Journal of Ethics* 3, no. 3 (1999): 196–200.

3 Robert Wachbroit, "A Genealogy of Virtues," *Yale Law Journal* 92, no. 3 (1983): 564–576.

4 Stephen Mulhall, "Liberalism, Morality and Rationality," in *After MacIntyre: Critical Perspectives on the Work of Alasdair MacIntyre*, ed. John Horton and Susan Mendus (Cambridge: Polity Press, 1994), 220.

5 Alasdair MacIntyre, *After Virtue* (London: Duckworth, 2007), .

6 MacIntyre, *After Virtue*, 269.

7 See Alasdair MacIntyre, "Intractable Moral Disagreements," in *Intractable Disputes about the Natural Law: Alasdair MacIntyre and Critics*, ed. Laurence Cunningham (Notre Dame, IN: University of Notre Dame Press, 2009), 1–52.

8 MacIntyre, "Postscript to the Second Edition," *After Virtue*, 268–69.

9 Horton and Mendus, *After MacIntyre*.

10 Alasdair MacIntyre, "A Partial Response to my Critics," in *After MacIntyre*, 293.

11 MacIntyre, "A Partial Response to my Critics," *After MacIntyre*, 293.

12 MacIntyre, "Prologue to the Third Edition," *After Virtue*, vii.

13 MacIntyre, "Postscript to the Second Edition," *After Virtue*, 272–78.

14 Alasdair MacIntyre, *Whose Justice? Which Rationality?* (Notre Dame, Indiana: University of Notre Dame Press, 1988), 7.

15 MacIntyre, *Whose Justice? Which Rationality?*, ix.

16 MacIntyre, *Whose Justice? Which Rationality?*, ix.

MODULE 10
THE EVOLVING DEBATE

KEY POINTS

- Alasdair MacIntyre consider the status of moral teleology* in terms of both biology and social roles.

- *After Virtue* has been responsible for the revival of an Aristotelian* approach to ethics and politics.

- *After Virtue* has helped bring about a revival of virtue ethics* in Christian theology,* as well as the "New Monastic"* social reform movement.

Uses and Problems

Alasdair MacIntyre continued to develop the ideas he first presented in *After Virtue*. In *Whose Justice? Which Rationality?*,[1] for example, he offered an account of the superior rationality of some moral traditions over others, while in his 1999 book *Dependent, Rational Animals*, he expanded his exploration of the *telos* (that is, the "end" or purpose) of human beings, arguing that biological facts, and not merely social roles or practices, allow us to make judgments.[2] Although this was a departure from the claim made in *After Virtue* that such biological facts were irrelevant,[3] MacIntyre maintained his commitment to the overall framework of Aristotle's virtue ethics.

The virtue ethicist Philippa Foot* made a similar claim in her book *Natural Goodness* (2001)[4] in which she writes of what she calls "Aristotelian categoricals." These are biological facts that allow us to speak of a virtue ethics with a teleological basis[5]—that is, they allow us to consider the existence of moral virtues in terms of the end purpose those morals might serve.

> 66 The modern philosophers whom we think of as having put virtue ethics on the map—Anscombe, Foot, Murdoch, Williams, MacIntyre, McDowell, Nussbaum, Slote—had all absorbed Plato and Aristotle, and in some cases also Aquinas. Their criticisms of 'modern moral philosophy' were no doubt shaped by what they had found insightful in those earlier writers and then found lacking in the moderns. 99
>
> Rosalind Hursthouse, *On Virtue Ethics*

To explain her argument by way of an analogy, we might make the factual claim: "This plant's roots will not absorb water." This claim can allow us to make a judgment—that the plant will not achieve the good of growing taller. Similarly, for Foot, a human being who does not have the capacity to keep promises or act courageously will not thrive, and may not even survive, as an organism.[6]

MacIntyre's and Foot's claims about the relationship between biology, purposes, and moral philosophy* remain controversial.

Schools of Thought

MacIntyre's claims in *After Virtue* provided a challenge to the moral theories of utilitarianism* (a moral philosophy based on the utility of an action) and deontology* (the study of moral obligations), and also to the very methods of modern moral philosophy itself. Indeed, MacIntyre helped to give rise to a movement that reinvigorated the virtue ethics of the Greek philosopher Aristotle, providing a serious alternative to the moral theories he challenged.

MacIntyre's *After Virtue* was one of the first major philosophical works to bring virtue ethics back into the public arena; ethicists such as Rosalind Hursthouse* of New Zealand have followed in his footsteps.[7] The rise of this new school of thought has enlivened the

debate over the nature of morality and its relationship to fields such as biology and sociology.*

MacIntyre's second major argument was that modern moral philosophers were wrong in the belief that it was possible to analyze abstract and universal moral questions. History, for MacIntyre, is essential to moral philosophy because, he believes, all moral concepts and arguments arise from their historical and social contexts. This methodology, known as "historicist,"* has had a major impact on many influential thinkers in political philosophy.*

It is also worth noting the rise of "New Monastic" movement, which owes a significant amount to MacIntyre's *After Virtue*. New Monastic communities strive to implement a Christian ethical framework by helping the poor and seeking to follow the moral teachings of Jesus. The movement's origins lie in the theologian* Jonathan R. Wilson's* book *Living Faithfully in a Fragmented World: Lessons for the Church from MacIntyre's 'After Virtue.'*[8] Wilson's book explores the ways in which MacIntyre's *After Virtue* can transform the practices of the Christian Church. He includes an analysis of how the "The Enlightenment* project" crept into the Church, as well as chapters on virtues, practices, and community—all topics drawn explicitly from Wilson's reading of *After Virtue*.

In Current Scholarship

MacIntyre's work has achieved significant influence in certain circles of moral and political philosophy. The Protestant* theologian Stanley Hauerwas,* one of the most influential Christian ethicists in the world today, mentions MacIntyre as a significant influence upon his thinking.[9] Indeed, in recent times a whole movement of virtue ethics has been generated within theological ethics. An anthology, *Virtues and Practices in the Christian Tradition*,[10] has been published exploring MacIntyre's impact on the last 25 years of moral theology. As one of the leaders of this movement, Stanley Hauerwas writes that he has

been influenced most by MacIntyre's arguments about the nature of human action and how to interpret it.[11]

Hauerwas's writing reflects MacIntyre's views on the virtues, on social practices, and on the Christian Church as a small-scale moral community. He also agrees with MacIntyre's claims that communitarianism* is dangerously wrong because of its claims that the modern nation-state is an appropriate institution for seeking moral consensus.[12]

Finally, MacIntyre's *After Virtue* has given rise to an entire research project in the area of Aristotelian ethics and politics. A key figure in this project is the philosophy scholar Kelvin Knight,* who helped start both the International Society for MacIntyrean Enquiry (ISME) and the Centre for Aristotelian Studies in Ethics and Politics (CASEP) at London Metropolitan University. Both institutions support research and conferences on subjects surrounding the themes of *After Virtue*, as well as exploring the Aristotelian themes of MacIntyre's later work. Each organization has dozens of members around the world who have been inspired by MacIntyre's reinvigoration of Aristotle's virtue ethics.

NOTES

1 Alasdair MacIntyre, *Whose Justice? Which Rationality?* (Notre Dame, Indiana: University of Notre Dame Press, 1988).

2 Alasdair MacIntyre, *Dependent, Rational Animals: Why Human Beings Need the Virtues* (London: Duckworth, 1999), 88–98.

3 Alasdair MacIntyre, *After Virtue* (London: Duckworth, 2007), 196.

4 Philippa Foot, *Natural Goodness* (Oxford: Oxford University Press, 2001), 38–51.

5 Foot, *Natural Goodness*, 46.

6 Foot, *Natural Goodness*, 51.

7 Jean Porter, "Virtue Ethics," in *The Cambridge Companion to Christian Ethics*, ed. Robin Gill (Cambridge: Cambridge University Press, 2012), 98.

8 Jonathan R. Wilson, *Living Faithfully in a Fragmented World* (Harrisburg, PA: Trinity Press International, 1997).

9 Stanley Hauerwas, "The Virtues of Alasdair MacIntyre," *First Things* (October 2007), accessed October 22, 2013, http://www.firstthings.com/issue-archive.

10 Nancey Murphy, B. Kallenberg and M. Nation, eds., *Virtues and Practices in the Christian Tradition: Christian Ethics after MacIntyre* (Harrisburg, PA: Trinity Press, 1997).

11 Hauerwas, "The Virtues of Alasdair MacIntyre."

12 Alasdair MacIntyre, "A Partial Response to my Critics," in *After MacIntyre: Critical Perspectives on the Work of Alasdair MacIntyre*, John Horton and Susan Mendus, eds, (Cambridge: Polity Press, 1994), 302.

MODULE 11
IMPACT AND INFLUENCE TODAY

KEY POINTS

- *After Virtue* is still cited as a key challenge to universalist*
 political philosophy*—that is, political philosophy that
 claims a universal authority regardless of culture—and it is
 still recognized as a key player in the resurgence of virtue
 ethics.*
- *After Virtue* calls for the integration of history with moral
 philosophy,* and informs key thinkers in the field of virtue
 ethics.
- Many moral philosophers have assimilated the virtues into
 other ethical theories; many liberal* political philosophers
 have ceased to claim a universal concept of justice.

Position

Alasdair MacIntyre's *After Virtue* continues to contribute to ongoing
academic debates. Most importantly, perhaps, it has helped to revive
virtue ethics as an independent moral theory, informing the work of
figures such as Rosalind Hursthouse,* Roger Crisp,* and Stanley
Hauerwas.*

After Virtue was one of the most influential books to defend the
necessity of the virtues for twentieth-century moral philosophy.
Thanks to MacIntyre's desire to reach out both to philosophers and
ordinary people, his defense of virtue ethics has gone beyond the
academic world and into popular consciousness.

In addition, *After Virtue* has challenged the universalist assumptions
of liberal political philosophy. It remains a touchstone for those who
believe the values of liberal societies do not automatically constitute

> ❝ Virtue ethics] has been further developed in Alasdair MacIntyre's masterpiece *After Virtue*. Thereafter, 'virtue ethics' seemingly became the third type of ethics, beside 'deontological ethics' and 'teleological* ethics. ❞
>
> Lee Ming-huei, "Confucianism, Kant, and Virtue Ethics"

justice for all societies. It is, for instance, still cited in discussions of communitarian* critiques of the political thought of the influential political philosopher John Rawls* and others. MacIntyre's view was similar to those of the respected political philosophers Michael Sandel* and Charles Taylor.* The former criticized the fact that liberalism does not encourage a shared understanding of the good, and the latter argued that Rawls's conception of justice is overly universalistic. MacIntyre voiced both criticisms of liberalism in After Virtue.

Interaction

MacIntyre's criticism of the philosophical approaches known as deontology* and utilitarianism* has inspired many virtue ethicists over the past 30 years; among these are thinkers such as Rosalind Hursthouse, Stanley Hauerwas, and Kelvin Knight.* MacIntyre's work has also influenced philosophers such as Philippa Foot* and Peter Geach,*[1] who immediately preceded him in the virtue ethics tradition.

Foot argued in 2001 that biological facts can give rise to moral judgments and MacIntyre probably influenced this view,[2] as he had written an account of the relationship between biology and the virtues two years previously.[3] He was also a reviewer of Foot's account, arguing that the need that humans have for promise-keeping is necessary, but not enough to explain virtues like truthfulness.[4] Furthermore, After Virtue has influenced ethicists from both theological and non-Western traditions. These include proponents of both Confucian* ethics[5] and Christian virtue ethicists.[6]

MacIntyre mounted one of the first and most successful attacks of John Rawls's method of theorizing about the nature of justice. This ignited a controversy in the 1980s between liberals like Rawls and those scholars who rejected liberalism. The main contention of this latter group, which became known as "communitarians" (a title MacIntyre has consistently rejected), is that communities should seek to determine and pursue their own ideas of justice. MacIntyre's contribution was the historicist* thesis, according to which there is no universal, timeless concept of justice and that we can rationally decide between systems of moral philosophy.

The Continuing Debate

In response to MacIntyre and other critics, Rawls modified his position on the universal nature of political liberalism in the 1990s, acknowledging that although his concept of justice had appealed to broadly democratic societies, it was not necessarily universal.[7]

In the area of moral philosophy, some thinkers from other traditions have been critical of the virtue ethics movement that MacIntyre helped to begin. Some philosophers, among them the ethicist Martha Nussbaum,*[8] have even claimed that there is no such thing as a rival "virtue ethics" but that the virtues have always been part of historical deontological, utilitarian, or Humean moral theories (that is, derived from the moral theories of the eighteenth-century British philosopher David Hume*). To claim otherwise, she writes, as MacIntyre did in *After Virtue*, is to create a "confused story": "This story … is told with satisfaction by some, who see in the rejection of the ambitious abstract theories of the Enlightenment* the best hope for an ethics that is realistic, historically grounded, perceptive, and worldly."[9]

These are clear allusions to MacIntyre's historically minded work in *After Virtue*. Indeed, Nussbaum goes on to claim of MacIntyre's account: "Thus virtuous action is a matter of authority and tradition:

one has to be assigned a role, and one has to have internalized that role so well that one simply does it without reflecting."[10]

It seems that Nussbaum, along with other moral philosophers, believes MacIntyre was essentially calling for a return to a tightly ordered social structure such as the Ancient Greek city-state. But it could be argued that MacIntyre's work has never argued for a social structure like this, where roles in society are assigned by those in authority. MacIntyre is simply committed to the view that social roles—however we come by them—inevitably define our lives and require that we possess the virtues.[11]

NOTES

1 See Philippa Foot, *Natural Goodness* (Oxford: Oxford University Press, 2001); and Peter Geach, *Truth and Hope* (Notre Dame, IN: University of Notre Dame Press, 2001); and Alasdair MacIntyre, "Virtues in Foot and Geach," *Philosophical Quarterly* 52, no. 209 (2002): 621–31.

2 Foot, *Natural Goodness*, 44–8.

3 Alasdair MacIntyre, *Dependent, Rational Animals: Why Human Beings Need the Virtues* (London: Duckworth, 1999), 88–98.

4 MacIntyre, "Virtues in Foot and Geach," 621–31.

5 Liu Liangjian, "Virtue Ethics and Confucianism: A Methodological Reflection," in *Virtue Ethics and Confucianism*, ed. Stephen C. Angle and Michael Slote (New York: Routledge, 2013), 67; Alasdair MacIntyre, "Questions for Confucians" in *Confucian Ethics*, ed. Kwang-loi Shun and David Wong (Cambridge: Cambridge University Press, 2004).

6 Jean Porter, "Virtue Ethics" in *The Cambridge Companion to Christian Ethics*, ed. Robin Gill (Cambridge: Cambridge University Press, 2012), 87–99.

7 Will Kymlicka, "Community" in *A Companion to Contemporary Political Philosophy*, ed. Robert E. Goodin and Philip Pettit (Oxford: Blackwell, 1993), 366–78; see also Daniel Bell, "Communitarianism," in *The Stanford Encyclopedia of Philosophy* (Spring 2012 edition), ed. Edward N. Zalta, accessed October 22, 2013, http://plato.stanford.edu/archives/spr2012/entries/communitarianism/.

8 See Martha Nussbaum, "Virtue Ethics: A Misleading Category?," *Journal of Ethics* 3, no. 3 (1999): 163–201.

9 Nussbaum, "Virtue Ethics," 164.

10 Nussbaum, "Virtue Ethics," 196.

11 Alasdair MacIntyre, *After Virtue* (London: Duckworth, 2007), 196–98.

MODULE 12
WHERE NEXT?

KEY POINTS

- *After Virtue* will continue to bring virtues to the center of the field of moral philosophy.*
- The work's impact will continue to grow through the already existing school of Aristotelian* ethics, as well as grassroots movements like "New Monasticism."*
- *After Virtue* is key to understanding the development in moral philosophy in the second half of the twentieth century.

Potential

Since Alasdair MacIntyre's *After Virtue*, virtue ethics* has become an increasingly important area of study and it is likely that the text will remain key to the fields of moral philosophy and political theory. Similarly, MacIntyre's historicist* approach will continue to be influential in the field of political philosophy.* Those political philosophers who support ideas of universal justice or rights or moral obligations must answer his claim that such moral concepts are to be found only within particular historical and political situations. As MacIntyre writes:"Morality which is no particular society's morality is to be found nowhere."[1]

On a popular level, disillusionment with capitalist* and liberal* systems has grown in the three decades since the publication of *After Virtue*. The global banking collapse of 2008 has renewed interest in MacIntyre's work, while he—as an advocate of small-scale forms of community—remains critical of both political liberalism and the international finance industry.[2] His alternative vision of human good

> 66 MacIntyre's work is often dismissed as too extreme to be taken seriously. In fact, MacIntyre's work is extreme, but we live in extreme times. And though he is certainly critical of some of the developments associated with modernity, Alasdair MacIntyre is also a constructive thinker who has sought to help us repair our lives by locating those forms of life that make possible moral excellence. 99
>
> Ian Morris, *Why the West Rules—For Now*

laid out in *After Virtue* remains relevant for all those who find political liberalism and global capitalism problematic.

MacIntyre's thought, however, is not communitarian*: he does not see the reform of the state as the answer to our moral problems. So it may be difficult for his followers to know how to live and act virtuously in relation to the modern state and the global financial system.

Future Directions

In 2007, the philosophy scholar Kelvin Knight* and several others founded the International Society for MacIntyrean Enquiry at London Metropolitan University and the society holds conferences annually on MacIntyre's writings. Knight also helped to found the Centre for Contemporary Aristotelian Studies in Ethics and Politics at London Metropolitan University. This research center is part of the revival of interest in Aristotle's contributions to contemporary political life—for which Alasdair MacIntyre, seen as the reformer of Aristotle's ethics, notably in *After Virtue*, has been largely responsible.

Knight's *Aristotelian Philosophy: Ethics and Politics from Aristotle to MacIntyre* (2007) credits MacIntyre with changing Aristotle's thought from an oppressive moral system to a revolutionary one.[3] Knight has also contributed to the growth of popular awareness of MacIntyre's

work, having edited *The MacIntyre Reader.*[4]

MacIntyre's work on virtue ethics has also influenced virtue-based approaches to ethics in Chinese philosophy. Entire books have been published exploring the relationship between MacIntyre's ethics and the virtue ethics of Confucianism,* for instance.[5]

Finally, MacIntyre's *After Virtue* has made a significant contribution to Christian ethics in the late-twentieth and early-twenty-first centuries. The book has influenced important Christian thinkers across several denominations, among them the Protestant* scholars Stanley Hauerwas* and John Milbank* and the Roman Catholic* scholar Jean Porter.* We can assume that MacIntyre's influence will continue to grow through the thinking of these theologians.

Summary

Over the past 30 years, the arguments made by MacIntyre in *After Virtue* have contributed to the revival of the neo-Aristotelian tradition of "virtue ethics."[6] This revival has given virtue ethics a significant place as a rival to the moral theory of utilitarianism* and deontology.* MacIntyre's arguments about the nature of a virtue, his description of the place of virtues within social and political life, and his critique of modern moral philosophy constitute a coherent and appealing moral system. Any philosopher wanting to engage meaningfully with moral philosophy, and especially the field of virtue ethics, must take the work's arguments into account.

This revival of virtue ethics is not only a matter for the academic arena, however. MacIntyre considers the arguments he makes in the book to be deeply important for the way everyone thinks and acts in our world. On the last page of *After Virtue*, MacIntyre makes a plea for civility and virtue: "What matters at this stage is the construction of local forms of community within which civility and the intellectual and moral life can be sustained through the new dark ages which are already upon us … This time however the barbarians are not waiting

beyond the frontiers; they have already been governing us for some time."[7] In response, some neo-Aristotelians have used MacIntyre's concepts to call for corporate change. Keith Breen* of Queen's University in Belfast has used MacIntyre's idea of practice to propose what he regards as a more emancipated, alternative notion of human productivity. Geoff Moore* of the University of Durham has called for virtue ethics to be applied to corporate social responsibility and fair trade.[8]

The arguments made in *After Virtue* provide the intellectual framework for a wide-ranging cultural movement. Given its radical critique of modern moral philosophy and its contribution to the neo-Aristotelian movements in moral and political philosophy, *After Virtue* will endure as an influential and provocative text for the general reader and the academic alike.

NOTES

1 Alasdair MacIntyre, "Postscript to the Second Edition," *After Virtue* (London: Duckworth, 2007), 265.

2 John Cornwell, "MacIntyre on Money," *Prospect* (October 20, 2010), accessed October 22, 2013, http://www.prospectmagazine.co.uk/magazine/alasdair-macintyre-on-money/#.UmZvjpTwKrM.

3 Kelvin Knight, *Aristotelian Philosophy: Ethics and Politics from Aristotle to MacIntyre* (Cambridge: Polity Press, 2007), 223.

4 Kelvin Knight, ed., *The MacIntyre Reader* (Notre Dame, IN: University of Notre Dame Press, 1998).

5 See *Confucian Ethics*, ed. Kwang-loi Shun and David Wong (Cambridge: Cambridge University Press, 2004); and *Virtue Ethics and Confucianism*, ed. Stephen C. Angle and Michael Slote, (New York: Routledge, 2013).

6 Rosalind Hursthouse, *On Virtue Ethics* (Oxford: Oxford University Press, 1999), 26.

7 MacIntyre, *After Virtue*, 263.

8 Website for Contemporary Aristotelian Studies in Ethics and Politics, accessed February 24, 2015, https://metranet.londonmet.ac.uk/depts/lgir/research-centres/casep/staff/uk-members.cfm.

GLOSSARY

GLOSSARY OF TERMS

Anglicanism: a denomination of Protestant Christianity founded in the United Kingdom. Though Anglicanism now has worldwide followers, it developed when King Henry VIII of England was denied a divorce by the Pope.

Atheism: the denial of the existence of God; atheists hold that there exists no being which is eternal, all-powerful, all-knowing, and all-good.

Capitalism: a theory of economics and politics in which the means of producing goods and profits are held by private individuals, rather than by the state. Global capitalism involves free trade across state boundaries and a complex system of investment in international corporations.

Celtic: an ethnic designation for the pre-Roman people of the British Isles and other parts of Europe, notably present-day France and parts of present-day Spain and Germany.

Communitarianism: the theory and practice of social organization along the lines of small, self-governing communities.

Confucian ethics: a branch of ethics which has its roots in the Chinese philosophy of Confucius, who lived in the fifth and sixth centuries B.C.E. Confucian ethics focuses on the virtues, particularly practical questions about duty to kin versus the wider social community.

Deontology: a moral philosophy that owes much to the Prussian philosopher Immanuel Kant. It states that an action is right insofar as a rational agent can will that it should be universal, and wrong insofar as he cannot.

Dialectical: an approach that brings two or more rival theories into conversation so that a synthesis, or compromise, of the rival approaches can be reached.

Emotivism: the reduction of moral claims to emotional responses of approval or disapproval.

Enlightenment: a period in European cultural history, roughly from the late seventeenth to the late eighteenth century, characterized by a turn towards rational thought.

Existentialism: a philosophical school that developed on the European continent during the 1800s and flourished in the first half of the twentieth century. Existentialists focus on themes like the loss of meaning and values in Western culture and individual lives, as well as the implications of the loss of belief in God.

Gaelic: a Celtic people who inhabited parts of the northern British Isles before the arrival of the Romans (and the Angles and the Saxons who followed them).

Historicism: a methodological approach to moral philosophy that places a premium on the historical contexts in which philosophical concepts and theses arise. It is an alternative to analytic moral philosophy in that it does not see moral disagreements as debates about a timeless and abstract thing called "morality."

Homeric age: the period in Ancient Greece about which the poet Homer composed his poems *The Iliad* and *The Odyssey*. This period is characterized by a system of honor, family and clan loyalties, and excellence in battle.

Incommensurability: describing the difficulty of reconciling competing moral theories owing to the lack of a shared standard of rationality.

International relations: a sub-discipline of political science that focuses on the relations between states and nations and often particularly on the foreign policy of single states or allied states.

Kantian ethics: an ethical system that follows the thought of the philosopher Immanuel Kant. It is very closely related to deontology, and it states that an action is immoral if it cannot be willed to be done universally.

Liberalism: the view that liberty is the most important thing for the state to prioritize. Accordingly, liberals hold that the primary good of a political system is to prevent one conception of the good from taking control of the political sphere.

Marxism: the name given to the political system advocated by Karl Marx. It emphasized an end to capitalism by taking control of the means of production from individuals and placing it in the hands of central government.

Metaphysical biology: MacIntyre's phrase for the teleological account of human biology upon which Aristotle based his account of virtue ethics. This now-defunct account held that certain purposes are built into human biology.

Middle Ages: a period of Western history from about 500 to 1500 C.E. beginning after the fall of the Roman Empire. In this period the Roman Catholic Church dominated in the fields of politics, science, and philosophy.

Modernity: the philosophical, social, and political outlook that arose from the thinking of the Enlightenment (in the mid-seventeenth and eighteenth centuries). It defined much of twentieth-century life in the West, and emphasizes individuality, political independence, and radical skepticism.

Moral philosophy: a sub-discipline of philosophy that focuses on both the theoretical and practical aspects of morality. It seeks primarily to answer the questions, what is the nature of the good life, and, how ought we to live?

Nationalism: the identification of oneself with the project represented by one's nation. It can either signify a call for the independence of one's nation, pride in one's nation, or the superiority of one's nation over all others.

New Monasticism: the New Monastic movement comprises Protestant religious communities partly inspired by Alasdair MacIntyre and *After Virtue*.

Newtonian revolution: the name for the shift in seventeenth-century theories of attraction between objects from Aristotle's theories to those described by Isaac Newton's principles of universal gravitation.

Paradigm: the term coined by the philosopher of science Thomas Kuhn's term for a set of practices that support the articulation, understanding, and incorporation of scientific data at a particular time.

Political philosophy: a sub-discipline of philosophy that seeks to determine the nature of civic principles such as justice, equality, and fairness. It is closely related to moral philosophy and political science.

Protestant: one of the three main branches of Christianity (along with Roman Catholicism and Eastern Orthodoxy). Protestants split from Roman Catholics during the sixteenth century over beliefs about the nature of certain rituals and the means of salvation.

Relativism: the belief that no single moral theory or system can be said to be superior to others. One's moral system is determined by one's social context and therefore is justified relative to that context but not outside of it.

Relativity: refers to a scientific theory advanced in 1905 by Albert Einstein (1879–1955) that has largely replaced the mechanical physics of Isaac Newton. The theory of relativity holds that space and time form a single continuum and that gravity can therefore affect the passage of time itself.

Roman Catholic Church: one of the principal Christian denominations (numbering over a billion members) together with the Eastern Orthodox and Protestant denominations. The Roman Catholic Church traces its heritage back to Jesus Christ and his disciples.

Sociology: an academic discipline that studies the nature of social behavior, social structures, and social change. It uses scientific methods as well as critical analysis.

Soviet Union: a communist political union of states that was established in 1922. It was comprised of Russia and many Eastern European and Eurasian states. It collapsed in 1991.

Stalinism: the repressive form of communism that was instituted in the Soviet Union under Joseph Stalin.

Teleology: originates from the Greek word *telos*, meaning "end" or "purpose." It refers to the study of whether human nature has definite and inherent biological or metaphysical purposes.

Theism: the belief that an all-powerful, all-knowing, and perfectly good God exists.

Theology: the discipline that studies the nature and action of God. It also explores human relationships to the divine and divine revelation.

Universalism: a theory that has pretensions of universal scope and authority over human beings. A universalist theory would therefore have absolute authority, despite cultural differences and disagreements.

Utilitarianism: a moral philosophy developed in the nineteenth century by Jeremy Bentham, which asserts that moral goodness lies exclusively in the maximizing of pleasure and the minimizing of pain for the greatest number of people.

Virtue ethics: a tradition of ethical enquiry that emphasizes the primacy of the development of the virtues (such as courage, prudence, temperance, and charity) in the lives of moral agents.

PEOPLE MENTIONED IN THE TEXT

Elizabeth Anscombe (1919–2001) was a British philosopher noted for her work on ethics and her passionate advocacy of the work of the Austrian philosopher Ludwig Wittgenstein (1889–1951). *Intention* (1957) and "Modern Moral Philosophy" (1958) are among her best-known publications.

Thomas Aquinas (1225–74) was a Roman Catholic theologian and philosopher whose greatest work, *Summa Theologiae* (1265–74) integrated Augustinian Catholic theology and the newly rediscovered ethical writings of Aristotle.

Aristotle (384–322 B.C.E.) was an Athenian philosopher, disciple of Plato, and one of the most influential philosophers of all time. His major works include *Metaphysics*, *Nicomachean Ethics*, and *Politics*, which became the basis of a longstanding moral tradition in Western philosophy.

Jane Austen (1775–1817) was an English novelist of the early Romantic period. Her themes include virtues and vices in middle and upper-class English life of the early nineteenth century.

Jeremy Bentham (1748–1832) was a British moral philosopher and social reformer. He is most closely associated with the moral philosophy of utilitarianism.

Simon Blackburn (b. 1944) is a prominent British philosopher and retired Bertrand Russell Professor of Philosophy at the University of Cambridge. His books are in the school of Hume's philosophy and include *Spreading the Word* (1984) and *Essays in Quasi-Realism* (1993).

Keith Breen is a senior lecturer in political and social theory at Queen's University, Belfast. He writes on political ethics, modernity, and intersubjectivity.

R. G. Collingwood (1889–1943) was an Oxford University philosopher of history and archaeologist. His most influential work was *The Idea of History* (1946), and this provided the methodological foundation for historicism in moral philosophy.

Roger Crisp (b. 1961) is professor of moral philosophy at the University of Oxford. He is an expert on Aristotle and has written *Reasons and the Good* (2006).

Philippa Foot (1920–2010) was a British philosopher noted for her works in ethics. *Natural Goodness* (2001) is her most original contribution to the field of moral philosophy.

Peter Geach (1916–2013) was a British philosopher and emeritus professor of logic at the University of Leeds. He was notable for his work in the history of philosophy and the logical principles of philosophy.

Stanley Hauerwas (b. 1940) is an American theologian, noted for his work in virtue ethics. A long-serving professor at Duke University, he is the author of more than 40 books, including *A Community of Character* (1981), and was acclaimed as "America's Best Theologian" by *Time* magazine in 2001.

G. W. F. Hegel (1770–1831) was a philosopher who belonged to the school of German Idealism. He is best known for his teleological view of history, which he held to be the inevitable unfolding of greater consciousness.

Thomas Hobbes (1588–1679) was an English Enlightenment philosopher. He is best known for his work in political philosophy, most notably *Leviathan* (1668).

John Horton is professor of political philosophy at Keele University in the United Kingdom. Together with Susan Mendus, he edited *After MacIntyre: Critical Perspectives on the Work of Alasdair MacIntyre* (1994).

David Hume (1711–76) was an influential British Empiricist philosopher who wrote *Dialogues Concerning Natural Religion* (1779) and *Enquiry into the Principles of Morals* (1751). His moral theory sought to ground ethics in the human sentiments or feelings.

Rosalind Hursthouse (b. 1943) is professor of philosophy at the University of Auckland, New Zealand. She is a prominent neo-Aristotelian virtue ethicist whose major works are "Virtue Theory and Abortion" (1991) and *On Virtue Ethics* (1999).

Immanuel Kant (1724–1804) was one of the most influential philosophers of the Enlightenment period. He was the author of dozens of works, including *Critique of Pure Reason* (1781) and *Groundwork for the Metaphysics of Morals* (1785), and he argued that ethics ought to be grounded in rationality.

Søren Kierkegaard (1813–55) was a Danish philosopher, the father of existentialism, and author of *Either/Or* (1843). Kierkegaard argued that one must authenticate one's own moral system through a tremendous act of will.

Kelvin Knight is a lecturer in philosophy at London Metropolitan University. He specializes in Aristotelian and MacIntyrean philosophy and ethics, and his books include *The MacIntyre Reader* (1998) and *Aristotelian Philosophy* (2013).

Thomas Kuhn (1922–96) was one of the most important philosophers of science of the twentieth century. His book *The Structure of Scientific Revolutions* (1962) brings history to bear upon the philosophy of science, much as historicists bring history to bear upon moral philosophy.

Donald N. Levine (1931–2015) was an American sociologist and a long-term professor of sociology at the University of Chicago. He was also a renowned Ethiopian scholar and founder of the Aikido Ethiopia Project.

John Locke (1632–1704) was an English philosopher of the Enlightenment, hailed as "The Father of Classical Liberalism." Among his most influential works are *Two Treatises of Government* (1689) and *An Essay Concerning Human Understanding* (1689).

John McDowell (b. 1942) is a contemporary philosopher of mind and moral philosopher. He has contributed to Aristotelian ethics and is the author of *Mind and World* (1994).

Karl Marx (1818–83) was a German philosopher, economist and revolutionary who was responsible for the development of communism. His major work, *The Manifesto of the Communist Party* (1848), argued for a moral alternative to capitalism.

Susan Lesley Mendus (b. 1951) is a prominent Welsh political philosopher. She is currently professor emerita of political philosophy at the University of York.

John Milbank (b. 1952) is a Christian philosopher who specializes in ethics and politics. He is the author of *Theology and Social Theory* (1990) and is professor of religion, politics and ethics at the University of Nottingham.

John Stuart Mill (1806–73) was an influential British philosopher and student of Jeremy Bentham. Mill focused on issues in moral and political philosophy, and his major works are *Utilitarianism* (1861) and *On Liberty* (1859).

Geoff Moore is professor of business ethics and deputy dean (learning & teaching) in the Business School of Durham University. He is a founding member of the UK Association of European Business Ethics Network (EBEN-UK).

Stephen Mulhall (b. 1962) is a philosopher at the University of Oxford. He is an expert on Wittgenstein and Heidegger.

Isaac Newton (1643–1727) was a British mathematician and scientist who invented calculus and formulated the universal theory of gravitation. His most influential works are *Principia Mathematica* (1687) and *Opticks* (1704).

Friedrich Nietzsche (1844–1900) was a German philosopher who attacked traditional morality and explored the ramifications of the collapse of belief in God. His most influential books, including *Geneology of Morals* (1887) and *Twilight of the Idols* (1889), argue that a "slave morality" had existed since Socrates and that moral philosophy should be concerned with making oneself a superman.

Robert Nozick (1938–2002) was an American philosopher noted for his book *Anarchy, State, and Utopia* (1974), a response to the work of the philosopher John Rawls that emphasized the cardinal importance of individual liberty.

Martha Nussbaum (b. 1947) is Ernst Freund Distinguished Service Professor of Law and Ethics at the University of Chicago. She is author

of *The Fragility of Goodness* (1986) and *Upheavals of Thought: the Intelligence of Emotions* (2001), and she seeks to complement Kantian ethics with Aristotle.

Onora O'Neill (b. 1941) is a British philosopher and a member of the House of Lords. Her research focuses on issues in moral philosophy, as well as biomedical issues.

Plato (c. 429—347 B.C.E.) is one of the most important philosophers in history. He was a disciple of Socrates and his dialogues cover most of the basic issues across the entire range of philosophical discourse—encompassing ethics, politics, knowledge, and God.

Jean Porter is a Roman Catholic moral theologian and the John O'Brien Professor of Theology at the University of Notre Dame in the United States. She is author of the influential *Nature as Reason: a Thomistic Theory of the Natural Law* (2005).

Hilary Putnam (b. 1926) is professor emeritus at Harvard University. He has published extensively in ethics, metaphysics and epistemology, including *Ethics Without Ontology* (2004).

James Rachels (1941–2003) was an *American moral philosopher, a renowned ethicist and advocate of animal rights. He spent 26 years teaching at the* University of Alabama at Birmingham.

John Rawls (1921–2002) was a Harvard University professor and one of the most influential political philosophers of the twentieth century. His masterpiece, *A Theory of Justice* (1971), forms the foundation of much contemporary liberal political theory.

Michael Sandel (b. 1953) is an American political philosopher and a

professor at Harvard University. His *Liberalism and the Limits of Justice* (1982) contains a critical analysis of *A Theory of Justice* (1971) by John Rawls.

Socrates (469–399 B.C.E.) is perhaps the father of the Western philosophical tradition. Although Socrates did not write anything himself, his thinking, mediated through his pupil Plato and other authors in Ancient Athens, transformed the way philosophy was conceived.

Joseph Stalin (1878–1953) led the Soviet Union from the mid-1920s until his death in March 1953. He is noted for his repressive domestic policy and for the atrocities that occurred during his rule.

Charles Taylor (b. 1931) is a Canadian political philosopher, currently professor emeritus at McGill University in Montreal. A practicing Roman Catholic, he ran four times for election to the Canadian House of Commons in the 1960s. His most influential work is *A Secular Age* (2007).

Giambattista Vico (1668–1744) was an Italian historian and philosopher of history whose most influential work was *The New Science* (1725). He argued for a highly evaluative approach to historical study.

Robert Wachbroit is associate professor at the University of Maryland School of Medicine. He has published papers on practical ethics and the ethics of research.

Jonathan R. Wilson is an American theologian, currently associate professor of systematic theology at Westmont College in the United States. His work has provided inspiration for the New Monasticism movement.

WORKS CITED

WORKS CITED

Anscombe, Elizabeth. "Modern Moral Philosophy." *Philosophy* 33, no. 124 (1958): 26–42.

Aristotle. *Nicomachean Ethics.* In *The Works of Aristotle*, Vol. 4, translated by Thomas Taylor. Somerset, UK: Prometheus Trust, 2002.

Breen, Keith. *After the Nation? Critical Reflections on Nationalism and Postnationalism.* London: Palgrave Macmillan, 2010.

Baggett, David and Jerry L. Walls. *Good God: The Theistic Foundations of Morality.* Oxford: Oxford University Press, 2011.

Bell, Daniel. "Communitarianism." In *The Stanford Encyclopedia of Philosophy* (Spring 2012 edition), edited by Edward N. Zalta. Accessed October 22, 2013. http://plato.stanford.edu/archives/spr2012/entries/communitarianism/.

Blackburn, Simon. "A Not-So-Common Good." *Times Literary Supplement,* May 5, 2000.

Casey, John. "Review of *After Virtue.*" *Philosophical Quarterly* 33 (1983): 296–300.

Contemporary Aristotelian Studies in Ethics and Politics. Accessed February 27, 2015. https://metranet.londonmet.ac.uk/depts/lgir/research-centres/casep/staff/rest-of-the-world.cfm.

Cornwell, John. "MacIntyre on Money." *Prospect,* October 20, 2010. Accessed October 22, 2013. http://www.prospectmagazine.co.uk/magazine/alasdair-macintyre-on-money/#.UmZvjpTwKrM.

D'Andrea, Thomas D. *Tradition, Rationality and Virtue: The Thought of Alasdair MacIntyre.* Burlington, VT: Ashgate, 2006.

Feinberg, Walter. "On *After Virtue.*" *Theory and Society,* 13, no. 2 (1984): 249–62.

Foot, Philippa. "Moral Arguments." *Mind* 67, no. 268 (1958): 502–13.

———*Natural Goodness*. Oxford: Oxford University Press, 2001.

———*Virtues and Vices and Other Essays in Moral Philosophy.* Berkeley:

University of California Press, 1978.

Geach, Peter. *Truth and Hope.* Notre Dame, IN: University of Notre Dame Press, 2001.

———— *The Virtues*. Cambridge: Cambridge University Press, 1977.

Gress, David. *From Plato to Nato*. New York: The Free Press, 1998.

Hauerwas, Stanley. "The Virtues of Alasdair MacIntyre." *First Things,* October 2007. Accessed October 22, 2013. http://www.firstthings.com/article/2007/09/004-the-virtues-of-alasdair-macintyre 6.

Horton, John, and Susan Mendus, eds. *After MacIntyre: Critical Perspectives on the Work of Alasdair MacIntyre*. Cambridge: Polity Press, 1994.

Hume, David. *A Treatise of Human Nature*, edited by L.A. Selby-Bigge and P.H. Nidditch, 2nd edition. Oxford: Oxford University Press, 1978.

Hursthouse, Rosalind. *On Virtue Ethics*. Oxford: Oxford University Press, 1999.

———— "Virtue Theory and Abortion." *Philosophy and Public Affairs* 20, no. 3 (1991): 223–46.

Kallenberg, Brad J., Nancy Murphy and Mark Thiessen Nation, eds. *Virtues and Practices in the Christian Tradition*. Harrisburg, PA: Trinity Press, 1997.

Knight, Kelvin. *Aristotelian Philosophy: Ethics and Politics from Aristotle to MacIntyre*. Cambridge: Polity Press, 2007.

Knight, Kelvin, ed. *The MacIntyre Reader*. Notre Dame, IN: University of Notre Dame Press, 1998.

Kymlicka, Will. "Community." In *A Companion to Contemporary Political Philosophy*, edited by Robert E. Goodin and Philip Pettit, 366–78. Oxford: Blackwell, 1993.

Levine, Donald N. "Review: Sociology After MacIntyre." *American Journal of Sociology* 89, no. 3 (1983): 700–7.

Liangjian, Liu. "Virtue Ethics and Confucianism: A Methodological Reflection." In *Virtue Ethics and Confucianism,* edited by Stephen C. Angle and Michael Slote. New York: Routledge, 2013.

Lutz, Christopher Stephen. "A Short History of Alasdair MacIntyre." In *Tradition in the Ethics of Alasdair MacIntyre: Relativism, Thomism, and Philosophy,* 22–24. Plymouth, UK: Lexington Books, 2009.

MacIntyre, Alasdair. *After Virtue*. 3rd ed. London: Duckworth, 2007.

————. *Dependent, Rational Animals*. London: Duckworth, 1999.

————. "Epistemological Crises, Dramatic Narrative and the Philosophy of Science." *The Monist* 60, no. 4 (1977): 453–72.

— — —. "Intractable Moral Disagreements." In *Intractable Disputes about the Natural Law: Alasdair MacIntyre and Critics*, edited by Laurence Cunningham. Notre Dame, IN: University of Notre Dame Press, 2009.

— — —. "Justice: A New Theory and some Old Questions." *Boston University Law Review* 52 (1972): 330–34.

— — —. *Marxism and Christianity*. 2nd ed. London: SCM Press, 1995.

— — —. "Objectivity in Morality and Objectivity in Science." In *Morals, Science and Sociality*, edited by H.T. Engelhardt and D. Callahan. Hastings-on-Hudson: Hastings Center, 1978.

— — —. "Questions for Confucians." In *Confucian Ethics*, edited by Kwang-loi Shun and David Wong. Cambridge: Cambridge University Press, 2004.

— — —. *A Short History of Ethics*. 2nd ed. London: Routledge & Kegan Paul, 1998.

— — —. *Three Rival Versions of Moral Enquiry*. Notre Dame, IN: University of Notre Dame Press, 1990.

— — —. "Virtues in Foot and Geach." *Philosophical Quarterly* 52, no. 209 (2002): 621–31.

— — —. *Whose Justice? Which Rationality?* Notre Dame, IN: University of Notre Dame Press, 1988.

McDowell, John. "Virtue and Reason." *The Monist* 62, no. 3 (1979): 331–50.

Milbank, John. *Theology and Social Theory*. Oxford: Blackwell, 1993.

Murphy, Mark C., ed. *Alasdair MacIntyre.* Cambridge: Cambridge University Press, 2003.

Murphy, Nancey, B. Kallenberg and M. Nation, eds. *Virtues and Practices in the Christian Tradition: Christian Ethics after MacIntyre.* Harrisburg, PA: Trinity Press, 1997.

Newman, Melanie. "Lazarus-Style Comeback." *Times Higher Education*, April 16, 2009. Accessed June 20, 2015. www.timeshighereducation.co.uk/features/lazarus-style-comeback/406157.article.

Nozick, Robert. *Anarchy, State and Utopia.* Oxford: Blackwell, 1974.

Nussbaum, Martha. "Review of *Whose Justice? Which Rationality?* by Alasdair MacIntyre." *New York Review of Books* 36 (1989): 40–1.

— — —. "Virtue Ethics: A Misleading Category?" *Journal of Ethics* 3, no. 3 (1999): 163–201.

O'Neill, Onora. "Kant After Virtue." *Inquiry* 26, no. 4 (1983): 387–405.

Porter, Jean. "Virtue Ethics." In *The Cambridge Companion to Christian Ethics*, edited by Robin Gill. Cambridge: Cambridge University Press, 2012.

Rachels, James. *The Elements of Moral Philosophy, Fourth Edition.* New York: McGraw-Hill, 2003.

Rawls, John. *Political Liberalism*. New York: Columbia University Press, 1993.

———. *A Theory of Justice*, revised edition. Oxford: Oxford University Press, 1999.

Wachbroit, Robert. "A Genealogy of Virtues." *Yale Law Journal* 92, no. 3 (1983): 564–576.

Wilson, Jonathan R. *Living Faithfully in a Fragmented World*. Harrisburg, PA: Trinity Press International, 1997.

THE MACAT LIBRARY
BY DISCIPLINE

The Macat Library By Discipline

AFRICANA STUDIES

Chinua Achebe's *An Image of Africa: Racism in Conrad's Heart of Darkness*
W. E. B. Du Bois's *The Souls of Black Folk*
Zora Neale Huston's *Characteristics of Negro Expression*
Martin Luther King Jr's *Why We Can't Wait*
Toni Morrison's *Playing in the Dark: Whiteness in the American Literary Imagination*

ANTHROPOLOGY

Arjun Appadurai's *Modernity at Large: Cultural Dimensions of Globalisation*
Philippe Ariès's *Centuries of Childhood*
Franz Boas's *Race, Language and Culture*
Kim Chan & Renée Mauborgne's *Blue Ocean Strategy*
Jared Diamond's *Guns, Germs & Steel: the Fate of Human Societies*
Jared Diamond's *Collapse: How Societies Choose to Fail or Survive*
E. E. Evans-Pritchard's *Witchcraft, Oracles and Magic Among the Azande*
James Ferguson's *The Anti-Politics Machine*
Clifford Geertz's *The Interpretation of Cultures*
David Graeber's *Debt: the First 5000 Years*
Karen Ho's *Liquidated: An Ethnography of Wall Street*
Geert Hofstede's *Culture's Consequences: Comparing Values, Behaviors, Institutes and Organizations across Nations*
Claude Lévi-Strauss's *Structural Anthropology*
Jay Macleod's *Ain't No Makin' It: Aspirations and Attainment in a Low-Income Neighborhood*
Saba Mahmood's *The Politics of Piety: The Islamic Revival and the Feminist Subject*
Marcel Mauss's *The Gift*

BUSINESS

Jean Lave & Etienne Wenger's *Situated Learning*
Theodore Levitt's *Marketing Myopia*
Burton G. Malkiel's *A Random Walk Down Wall Street*
Douglas McGregor's *The Human Side of Enterprise*
Michael Porter's *Competitive Strategy: Creating and Sustaining Superior Performance*
John Kotter's *Leading Change*
C. K. Prahalad & Gary Hamel's *The Core Competence of the Corporation*

CRIMINOLOGY

Michelle Alexander's *The New Jim Crow: Mass Incarceration in the Age of Colorblindness*
Michael R. Gottfredson & Travis Hirschi's *A General Theory of Crime*
Richard Herrnstein & Charles A. Murray's *The Bell Curve: Intelligence and Class Structure in American Life*
Elizabeth Loftus's *Eyewitness Testimony*
Jay Macleod's *Ain't No Makin' It: Aspirations and Attainment in a Low-Income Neighborhood*
Philip Zimbardo's *The Lucifer Effect*

ECONOMICS

Janet Abu-Lughod's *Before European Hegemony*
Ha-Joon Chang's *Kicking Away the Ladder*
David Brion Davis's *The Problem of Slavery in the Age of Revolution*
Milton Friedman's *The Role of Monetary Policy*
Milton Friedman's *Capitalism and Freedom*
David Graeber's *Debt: the First 5000 Years*
Friedrich Hayek's *The Road to Serfdom*
Karen Ho's *Liquidated: An Ethnography of Wall Street*

The Macat Library By Discipline

John Maynard Keynes's *The General Theory of Employment, Interest and Money*
Charles P. Kindleberger's *Manias, Panics and Crashes*
Robert Lucas's *Why Doesn't Capital Flow from Rich to Poor Countries?*
Burton G. Malkiel's *A Random Walk Down Wall Street*
Thomas Robert Malthus's *An Essay on the Principle of Population*
Karl Marx's *Capital*
Thomas Piketty's *Capital in the Twenty-First Century*
Amartya Sen's *Development as Freedom*
Adam Smith's *The Wealth of Nations*
Nassim Nicholas Taleb's *The Black Swan: The Impact of the Highly Improbable*
Amos Tversky's & Daniel Kahneman's *Judgment under Uncertainty: Heuristics and Biases*
Mahbub Ul Haq's *Reflections on Human Development*
Max Weber's *The Protestant Ethic and the Spirit of Capitalism*

FEMINISM AND GENDER STUDIES

Judith Butler's *Gender Trouble*
Simone De Beauvoir's *The Second Sex*
Michel Foucault's *History of Sexuality*
Betty Friedan's *The Feminine Mystique*
Saba Mahmood's *The Politics of Piety: The Islamic Revival and the Feminist Subject*
Joan Wallach Scott's *Gender and the Politics of History*
Mary Wollstonecraft's *A Vindication of the Rights of Woman*
Virginia Woolf's *A Room of One's Own*

GEOGRAPHY

The Brundtland Report's *Our Common Future*
Rachel Carson's *Silent Spring*
Charles Darwin's *On the Origin of Species*
James Ferguson's *The Anti-Politics Machine*
Jane Jacobs's *The Death and Life of Great American Cities*
James Lovelock's *Gaia: A New Look at Life on Earth*
Amartya Sen's *Development as Freedom*
Mathis Wackernagel & William Rees's *Our Ecological Footprint*

HISTORY

Janet Abu-Lughod's *Before European Hegemony*
Benedict Anderson's *Imagined Communities*
Bernard Bailyn's *The Ideological Origins of the American Revolution*
Hanna Batatu's *The Old Social Classes And The Revolutionary Movements Of Iraq*
Christopher Browning's *Ordinary Men: Reserve Police Batallion 101 and the Final Solution in Poland*
Edmund Burke's *Reflections on the Revolution in France*
William Cronon's *Nature's Metropolis: Chicago And The Great West*
Alfred W. Crosby's *The Columbian Exchange*
Hamid Dabashi's *Iran: A People Interrupted*
David Brion Davis's *The Problem of Slavery in the Age of Revolution*
Nathalie Zemon Davis's *The Return of Martin Guerre*
Jared Diamond's *Guns, Germs & Steel: the Fate of Human Societies*
Frank Dikotter's *Mao's Great Famine*
John W Dower's *War Without Mercy: Race And Power In The Pacific War*
W. E. B. Du Bois's *The Souls of Black Folk*
Richard J. Evans's *In Defence of History*
Lucien Febvre's *The Problem of Unbelief in the 16th Century*
Sheila Fitzpatrick's *Everyday Stalinism*

Eric Foner's *Reconstruction: America's Unfinished Revolution, 1863-1877*
Michel Foucault's *Discipline and Punish*
Michel Foucault's *History of Sexuality*
Francis Fukuyama's *The End of History and the Last Man*
John Lewis Gaddis's *We Now Know: Rethinking Cold War History*
Ernest Gellner's *Nations and Nationalism*
Eugene Genovese's *Roll, Jordan, Roll: The World the Slaves Made*
Carlo Ginzburg's *The Night Battles*
Daniel Goldhagen's *Hitler's Willing Executioners*
Jack Goldstone's *Revolution and Rebellion in the Early Modern World*
Antonio Gramsci's *The Prison Notebooks*
Alexander Hamilton, John Jay & James Madison's *The Federalist Papers*
Christopher Hill's *The World Turned Upside Down*
Carole Hillenbrand's *The Crusades: Islamic Perspectives*
Thomas Hobbes's *Leviathan*
Eric Hobsbawm's *The Age Of Revolution*
John A. Hobson's *Imperialism: A Study*
Albert Hourani's *History of the Arab Peoples*
Samuel P. Huntington's *The Clash of Civilizations and the Remaking of World Order*
C. L. R. James's *The Black Jacobins*
Tony Judt's *Postwar: A History of Europe Since 1945*
Ernst Kantorowicz's *The King's Two Bodies: A Study in Medieval Political Theology*
Paul Kennedy's *The Rise and Fall of the Great Powers*
Ian Kershaw's *The "Hitler Myth": Image and Reality in the Third Reich*
John Maynard Keynes's *The General Theory of Employment, Interest and Money*
Charles P. Kindleberger's *Manias, Panics and Crashes*
Martin Luther King Jr's *Why We Can't Wait*
Henry Kissinger's *World Order: Reflections on the Character of Nations and the Course of History*
Thomas Kuhn's *The Structure of Scientific Revolutions*
Georges Lefebvre's *The Coming of the French Revolution*
John Locke's *Two Treatises of Government*
Niccolò Machiavelli's *The Prince*
Thomas Robert Malthus's *An Essay on the Principle of Population*
Mahmood Mamdani's *Citizen and Subject: Contemporary Africa And The Legacy Of Late Colonialism*
Karl Marx's *Capital*
Stanley Milgram's *Obedience to Authority*
John Stuart Mill's *On Liberty*
Thomas Paine's *Common Sense*
Thomas Paine's *Rights of Man*
Geoffrey Parker's *Global Crisis: War, Climate Change and Catastrophe in the Seventeenth Century*
Jonathan Riley-Smith's *The First Crusade and the Idea of Crusading*
Jean-Jacques Rousseau's *The Social Contract*
Joan Wallach Scott's *Gender and the Politics of History*
Theda Skocpol's *States and Social Revolutions*
Adam Smith's *The Wealth of Nations*
Timothy Snyder's *Bloodlands: Europe Between Hitler and Stalin*
Sun Tzu's *The Art of War*
Keith Thomas's *Religion and the Decline of Magic*
Thucydides's *The History of the Peloponnesian War*
Frederick Jackson Turner's *The Significance of the Frontier in American History*
Odd Arne Westad's *The Global Cold War: Third World Interventions And The Making Of Our Times*

The Macat Library By Discipline

LITERATURE

Chinua Achebe's *An Image of Africa: Racism in Conrad's Heart of Darkness*
Roland Barthes's *Mythologies*
Homi K. Bhabha's *The Location of Culture*
Judith Butler's *Gender Trouble*
Simone De Beauvoir's *The Second Sex*
Ferdinand De Saussure's *Course in General Linguistics*
T. S. Eliot's *The Sacred Wood: Essays on Poetry and Criticism*
Zora Neale Huston's *Characteristics of Negro Expression*
Toni Morrison's *Playing in the Dark: Whiteness in the American Literary Imagination*
Edward Said's *Orientalism*
Gayatri Chakravorty Spivak's *Can the Subaltern Speak?*
Mary Wollstonecraft's *A Vindication of the Rights of Women*
Virginia Woolf's *A Room of One's Own*

PHILOSOPHY

Elizabeth Anscombe's *Modern Moral Philosophy*
Hannah Arendt's *The Human Condition*
Aristotle's *Metaphysics*
Aristotle's *Nicomachean Ethics*
Edmund Gettier's *Is Justified True Belief Knowledge?*
Georg Wilhelm Friedrich Hegel's *Phenomenology of Spirit*
David Hume's *Dialogues Concerning Natural Religion*
David Hume's *The Enquiry for Human Understanding*
Immanuel Kant's *Religion within the Boundaries of Mere Reason*
Immanuel Kant's *Critique of Pure Reason*
Søren Kierkegaard's *The Sickness Unto Death*
Søren Kierkegaard's *Fear and Trembling*
C. S. Lewis's *The Abolition of Man*
Alasdair MacIntyre's *After Virtue*
Marcus Aurelius's *Meditations*
Friedrich Nietzsche's *On the Genealogy of Morality*
Friedrich Nietzsche's *Beyond Good and Evil*
Plato's *Republic*
Plato's *Symposium*
Jean-Jacques Rousseau's *The Social Contract*
Gilbert Ryle's *The Concept of Mind*
Baruch Spinoza's *Ethics*
Sun Tzu's *The Art of War*
Ludwig Wittgenstein's *Philosophical Investigations*

POLITICS

Benedict Anderson's *Imagined Communities*
Aristotle's *Politics*
Bernard Bailyn's *The Ideological Origins of the American Revolution*
Edmund Burke's *Reflections on the Revolution in France*
John C. Calhoun's *A Disquisition on Government*
Ha-Joon Chang's *Kicking Away the Ladder*
Hamid Dabashi's *Iran: A People Interrupted*
Hamid Dabashi's *Theology of Discontent: The Ideological Foundation of the Islamic Revolution in Iran*
Robert Dahl's *Democracy and its Critics*
Robert Dahl's *Who Governs?*
David Brion Davis's *The Problem of Slavery in the Age of Revolution*

Alexis De Tocqueville's *Democracy in America*
James Ferguson's *The Anti-Politics Machine*
Frank Dikotter's *Mao's Great Famine*
Sheila Fitzpatrick's *Everyday Stalinism*
Eric Foner's *Reconstruction: America's Unfinished Revolution, 1863-1877*
Milton Friedman's *Capitalism and Freedom*
Francis Fukuyama's *The End of History and the Last Man*
John Lewis Gaddis's *We Now Know: Rethinking Cold War History*
Ernest Gellner's *Nations and Nationalism*
David Graeber's *Debt: the First 5000 Years*
Antonio Gramsci's *The Prison Notebooks*
Alexander Hamilton, John Jay & James Madison's *The Federalist Papers*
Friedrich Hayek's *The Road to Serfdom*
Christopher Hill's *The World Turned Upside Down*
Thomas Hobbes's *Leviathan*
John A. Hobson's *Imperialism: A Study*
Samuel P. Huntington's *The Clash of Civilizations and the Remaking of World Order*
Tony Judt's *Postwar: A History of Europe Since 1945*
David C. Kang's *China Rising: Peace, Power and Order in East Asia*
Paul Kennedy's *The Rise and Fall of Great Powers*
Robert Keohane's *After Hegemony*
Martin Luther King Jr.'s *Why We Can't Wait*
Henry Kissinger's *World Order: Reflections on the Character of Nations and the Course of History*
John Locke's *Two Treatises of Government*
Niccolò Machiavelli's *The Prince*
Thomas Robert Malthus's *An Essay on the Principle of Population*
Mahmood Mamdani's *Citizen and Subject: Contemporary Africa And The Legacy Of Late Colonialism*
Karl Marx's *Capital*
John Stuart Mill's *On Liberty*
John Stuart Mill's *Utilitarianism*
Hans Morgenthau's *Politics Among Nations*
Thomas Paine's *Common Sense*
Thomas Paine's *Rights of Man*
Thomas Piketty's *Capital in the Twenty-First Century*
Robert D. Putman's *Bowling Alone*
John Rawls's *Theory of Justice*
Jean-Jacques Rousseau's *The Social Contract*
Theda Skocpol's *States and Social Revolutions*
Adam Smith's *The Wealth of Nations*
Sun Tzu's *The Art of War*
Henry David Thoreau's *Civil Disobedience*
Thucydides's *The History of the Peloponnesian War*
Kenneth Waltz's *Theory of International Politics*
Max Weber's *Politics as a Vocation*
Odd Arne Westad's *The Global Cold War: Third World Interventions And The Making Of Our Times*

POSTCOLONIAL STUDIES

Roland Barthes's *Mythologies*
Frantz Fanon's *Black Skin, White Masks*
Homi K. Bhabha's *The Location of Culture*
Gustavo Gutiérrez's *A Theology of Liberation*
Edward Said's *Orientalism*
Gayatri Chakravorty Spivak's *Can the Subaltern Speak?*

The Macat Library By Discipline

PSYCHOLOGY

Gordon Allport's *The Nature of Prejudice*
Alan Baddeley & Graham Hitch's *Aggression: A Social Learning Analysis*
Albert Bandura's *Aggression: A Social Learning Analysis*
Leon Festinger's *A Theory of Cognitive Dissonance*
Sigmund Freud's *The Interpretation of Dreams*
Betty Friedan's *The Feminine Mystique*
Michael R. Gottfredson & Travis Hirschi's *A General Theory of Crime*
Eric Hoffer's *The True Believer: Thoughts on the Nature of Mass Movements*
William James's *Principles of Psychology*
Elizabeth Loftus's *Eyewitness Testimony*
A. H. Maslow's *A Theory of Human Motivation*
Stanley Milgram's *Obedience to Authority*
Steven Pinker's *The Better Angels of Our Nature*
Oliver Sacks's *The Man Who Mistook His Wife For a Hat*
Richard Thaler & Cass Sunstein's *Nudge: Improving Decisions About Health, Wealth and Happiness*
Amos Tversky's *Judgment under Uncertainty: Heuristics and Biases*
Philip Zimbardo's *The Lucifer Effect*

SCIENCE

Rachel Carson's *Silent Spring*
William Cronon's *Nature's Metropolis: Chicago And The Great West*
Alfred W. Crosby's *The Columbian Exchange*
Charles Darwin's *On the Origin of Species*
Richard Dawkin's *The Selfish Gene*
Thomas Kuhn's *The Structure of Scientific Revolutions*
Geoffrey Parker's *Global Crisis: War, Climate Change and Catastrophe in the Seventeenth Century*
Mathis Wackernagel & William Rees's *Our Ecological Footprint*

SOCIOLOGY

Michelle Alexander's *The New Jim Crow: Mass Incarceration in the Age of Colorblindness*
Gordon Allport's *The Nature of Prejudice*
Albert Bandura's *Aggression: A Social Learning Analysis*
Hanna Batatu's *The Old Social Classes And The Revolutionary Movements Of Iraq*
Ha-Joon Chang's *Kicking Away the Ladder*
W. E. B. Du Bois's *The Souls of Black Folk*
Émile Durkheim's *On Suicide*
Frantz Fanon's *Black Skin, White Masks*
Frantz Fanon's *The Wretched of the Earth*
Eric Foner's *Reconstruction: America's Unfinished Revolution, 1863-1877*
Eugene Genovese's *Roll, Jordan, Roll: The World the Slaves Made*
Jack Goldstone's *Revolution and Rebellion in the Early Modern World*
Antonio Gramsci's *The Prison Notebooks*
Richard Herrnstein & Charles A Murray's *The Bell Curve: Intelligence and Class Structure in American Life*
Eric Hoffer's *The True Believer: Thoughts on the Nature of Mass Movements*
Jane Jacobs's *The Death and Life of Great American Cities*
Robert Lucas's *Why Doesn't Capital Flow from Rich to Poor Countries?*
Jay Macleod's *Ain't No Makin' It: Aspirations and Attainment in a Low Income Neighborhood*
Elaine May's *Homeward Bound: American Families in the Cold War Era*
Douglas McGregor's *The Human Side of Enterprise*
C. Wright Mills's *The Sociological Imagination*

Thomas Piketty's *Capital in the Twenty-First Century*
Robert D. Putman's *Bowling Alone*
David Riesman's *The Lonely Crowd: A Study of the Changing American Character*
Edward Said's *Orientalism*
Joan Wallach Scott's *Gender and the Politics of History*
Theda Skocpol's *States and Social Revolutions*
Max Weber's *The Protestant Ethic and the Spirit of Capitalism*

THEOLOGY

Augustine's *Confessions*
Benedict's *Rule of St Benedict*
Gustavo Gutiérrez's *A Theology of Liberation*
Carole Hillenbrand's *The Crusades: Islamic Perspectives*
David Hume's *Dialogues Concerning Natural Religion*
Immanuel Kant's *Religion within the Boundaries of Mere Reason*
Ernst Kantorowicz's *The King's Two Bodies: A Study in Medieval Political Theology*
Søren Kierkegaard's *The Sickness Unto Death*
C. S. Lewis's *The Abolition of Man*
Saba Mahmood's *The Politics of Piety: The Islamic Revival and the Feminist Subject*
Baruch Spinoza's *Ethics*
Keith Thomas's *Religion and the Decline of Magic*

COMING SOON

Chris Argyris's *The Individual and the Organisation*
Seyla Benhabib's *The Rights of Others*
Walter Benjamin's *The Work Of Art in the Age of Mechanical Reproduction*
John Berger's *Ways of Seeing*
Pierre Bourdieu's *Outline of a Theory of Practice*
Mary Douglas's *Purity and Danger*
Roland Dworkin's *Taking Rights Seriously*
James G. March's *Exploration and Exploitation in Organisational Learning*
Ikujiro Nonaka's *A Dynamic Theory of Organizational Knowledge Creation*
Griselda Pollock's *Vision and Difference*
Amartya Sen's *Inequality Re-Examined*
Susan Sontag's *On Photography*
Yasser Tabbaa's *The Transformation of Islamic Art*
Ludwig von Mises's *Theory of Money and Credit*

Macat Disciplines

Access the greatest ideas and thinkers across entire disciplines, including

AFRICANA STUDIES

Chinua Achebe's *An Image of Africa:
Racism in Conrad's Heart of Darkness*

W. E. B. Du Bois's *The Souls of Black Folk*

Zora Neale Hurston's *Characteristics of Negro Expression*

Martin Luther King Jr.'s *Why We Can't Wait*

Toni Morrison's *Playing in the Dark:
Whiteness in the American Literary Imagination*

Macat analyses are available from all good bookshops and libraries.

Access hundreds of analyses through one, multimedia tool.

Macat Disciplines

Access the greatest ideas and thinkers across entire disciplines, including

FEMINISM, GENDER AND QUEER STUDIES

Simone De Beauvoir's
The Second Sex

Michel Foucault's
History of Sexuality

Betty Friedan's
The Feminine Mystique

Saba Mahmood's
*The Politics of Piety:
The Islamic Revival and
the Feminist Subject*

Joan Wallach Scott's
*Gender and the
Politics of History*

Mary Wollstonecraft's
*A Vindication of the
Rights of Woman*

Virginia Woolf's
A Room of One's Own

Judith Butler's
Gender Trouble

Macat analyses are available from all good bookshops and libraries.

Access hundreds of analyses through one, multimedia tool.

Join free for one month **library.macat.com**

Macat Disciplines

Access the greatest ideas and thinkers across entire disciplines, including

INEQUALITY

Ha-Joon Chang's, *Kicking Away the Ladder*

David Graeber's, *Debt: The First 5000 Years*

Robert E. Lucas's, *Why Doesn't Capital Flow from Rich To Poor Countries?*

Thomas Piketty's, *Capital in the Twenty-First Century*

Amartya Sen's, *Inequality Re-Examined*

Mahbub Ul Haq's, *Reflections on Human Development*

Macat analyses are available from all good bookshops and libraries.

Access hundreds of analyses through one, multimedia tool.

Join free for one month **library.macat.com**

Macat Disciplines

*Access the greatest ideas and thinkers
across entire disciplines, including*

CRIMINOLOGY

Michelle Alexander's
*The New Jim Crow:
Mass Incarceration in the
Age of Colorblindness*

**Michael R. Gottfredson
& Travis Hirschi's**
A General Theory of Crime

Elizabeth Loftus's
Eyewitness Testimony

**Richard Herrnstein
& Charles A. Murray's**
*The Bell Curve: Intelligence and
Class Structure in American Life*

Jay Macleod's
*Ain't No Makin' It:
Aspirations and Attainment in a
Low-Income Neighborhood*

Philip Zimbardo's
The Lucifer Effect

Macat Disciplines

*Access the greatest ideas and thinkers
across entire disciplines, including*

THE FUTURE OF DEMOCRACY

Robert A. Dahl's, *Democracy and Its Critics*
Robert A. Dahl's, *Who Governs?*
Alexis De Toqueville's, *Democracy in America*
Niccolò Machiavelli's, *The Prince*
John Stuart Mill's, *On Liberty*
Robert D. Putnam's, *Bowling Alone*
Jean-Jacques Rousseau's, *The Social Contract*
Henry David Thoreau's, *Civil Disobedience*

Macat Disciplines

Access the greatest ideas and thinkers across entire disciplines, including

TOTALITARIANISM

Sheila Fitzpatrick's, *Everyday Stalinism*
Ian Kershaw's, *The "Hitler Myth"*
Timothy Snyder's, *Bloodlands*

Macat analyses are available from all good bookshops and libraries.

Access hundreds of analyses through one, multimedia tool.

Join free for one month **library.macat.com**

Macat Pairs

Analyse historical and modern issues from opposite sides of an argument. Pairs include:

RACE AND IDENTITY

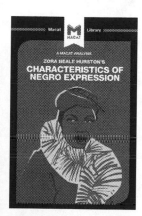

Zora Neale Hurston's
Characteristics of Negro Expression

Using material collected on anthropological expeditions to the South, Zora Neale Hurston explains how expression in African American culture in the early twentieth century departs from the art of white America. At the time, African American art was often criticized for copying white culture. For Hurston, this criticism misunderstood how art works. European tradition views art as something fixed. But Hurston describes a creative process that is alive, ever-changing, and largely improvisational. She maintains that African American art works through a process called 'mimicry'—where an imitated object or verbal pattern, for example, is reshaped and altered until it becomes something new, novel—and worthy of attention.

Frantz Fanon's
Black Skin, White Masks

Black Skin, White Masks offers a radical analysis of the psychological effects of colonization on the colonized.

Fanon witnessed the effects of colonization first hand both in his birthplace, Martinique, and again later in life when he worked as a psychiatrist in another French colony, Algeria. His text is uncompromising in form and argument. He dissects the dehumanizing effects of colonialism, arguing that it destroys the native sense of identity, forcing people to adapt to an alien set of values—including a core belief that they are inferior. This results in deep psychological trauma.

Fanon's work played a pivotal role in the civil rights movements of the 1960s.

Macat analyses are available from all good bookshops and libraries.

Access hundreds of analyses through one, multimedia tool.
Join free for one month **library.macat.com**

Macat Pairs

Analyse historical and modern issues from opposite sides of an argument. Pairs include:

INTERNATIONAL RELATIONS IN THE 21ST CENTURY

Samuel P. Huntington's
The Clash of Civilisations

In his highly influential 1996 book, Huntington offers a vision of a post-Cold War world in which conflict takes place not between competing ideologies but between cultures. The worst clash, he argues, will be between the Islamic world and the West: the West's arrogance and belief that its culture is a "gift" to the world will come into conflict with Islam's obstinacy and concern that its culture is under attack from a morally decadent "other."

Clash inspired much debate between different political schools of thought. But its greatest impact came in helping define American foreign policy in the wake of the 2001 terrorist attacks in New York and Washington.

Francis Fukuyama's
The End of History and the Last Man

Published in 1992, *The End of History and the Last Man* argues that capitalist democracy is the final destination for all societies. Fukuyama believed democracy triumphed during the Cold War because it lacks the "fundamental contradictions" inherent in communism and satisfies our yearning for freedom and equality. Democracy therefore marks the endpoint in the evolution of ideology, and so the "end of history." There will still be "events," but no fundamental change in ideology.

Macat Disciplines

Access the greatest ideas and thinkers across entire disciplines, including

MAN AND THE ENVIRONMENT

The Brundtland Report's, *Our Common Future*
Rachel Carson's, *Silent Spring*
James Lovelock's, *Gaia: A New Look at Life on Earth*
Mathis Wackernagel & William Rees's, *Our Ecological Footprint*

Macat analyses are available from all good bookshops and libraries.

Access hundreds of analyses through one, multimedia tool.
Join free for one month **library.macat.com**

Printed in the United States
by Baker & Taylor Publisher Services